IMAGES
of Rail

THE ONTARIO &
WESTERN RAILWAY
NORTHERN DIVISION

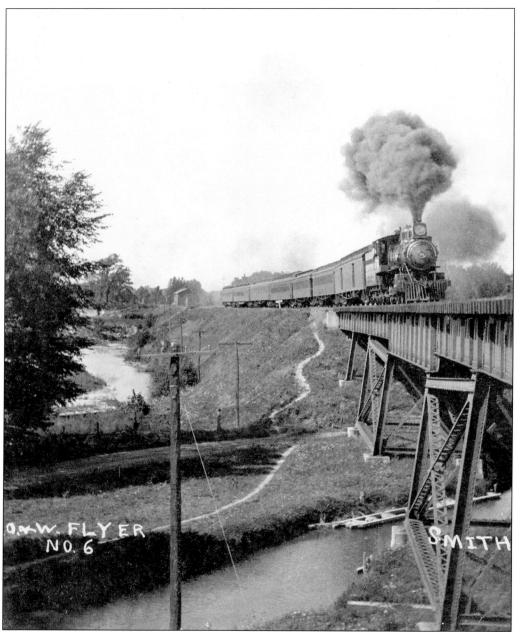

O.&W. FLYER
NO. 6

SMITH

Midway through its Northern Division crossing, southbound O & W train No. 6 bounds onto the Oneida Creek bridge just south of the Kenwood depot. Officially, the train's name was the Atlantic Express, but locally it was referred to as the Flyer. Either name pointed to the fact that the New York, Ontario & Western Railway was instrumental in providing satisfactory transportation to central New York. (Courtesy Bruce Tracy.)

IMAGES
of Rail

THE ONTARIO & WESTERN RAILWAY NORTHERN DIVISION

John Taibi

ARCADIA
PUBLISHING

Copyright © 2003 by John Taibi
ISBN 978-0-7385-1175-7

Published by Arcadia Publishing
Charleston, South Carolina

Printed in the United States of America

Library of Congress Catalog Card Number: 2003101015

For all general information contact Arcadia Publishing at:
Telephone 843-853-2070
Fax 843-853-0044
E-mail sales@arcadiapublishing.com
For customer service and orders:
Toll-Free 1-888-313-2665

Visit us on the Internet at www.arcadiapublishing.com

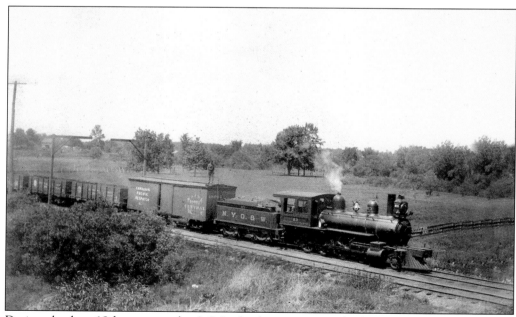

During the late 19th century, the 2-8-0 wheel arrangement for locomotives was well suited to handle the O & W's heavy freight trains over the Northern Division. In this period scene, Class-O Consolidation No. 83 is about to duck under the Lackawanna Railroad's overpass at Sherburne Four Corners with a southbound freight. This engine was built for the West Shore Railroad during 1883; the O & W acquired it three years later. (Author's collection.)

CONTENTS

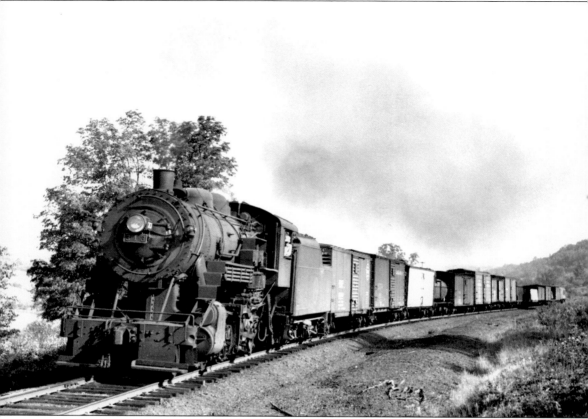

Trotting up the grade to Summit under a light stack, 2-8-0 No. 313 leads train No. 9 through the town of Guilford's countryside near Parkers. To the delight of the operating department, the engine crew's charge was running efficiently: the absence of smoke meant fuel savings for the Ontario & Western Railway. Robert F. Collins photographed this scene on August 30, 1941. (Courtesy Jack W. Farrell.)

INTRODUCTION

Following the Civil War, an especially severe outbreak of railroad fever developed in the central New York State communities lying between the New York Central Railroad, located in the Mohawk Valley, and the Erie Railway, which traversed the state's southern tier. These communities wished to enhance their prosperity by building rail lines that would connect to the earlier trunk-line railroads. While many small lines would connect a number of communities with either the New York Central or the Erie, one grand scheme that blossomed in the spring of 1866 would eclipse all other proposed railroads in the region.

The New York & Oswego Midland Railroad was designed to run diagonally across New York State from Oswego to a point on the Hudson River near New York City's great harbor. Because of its proposed route, the line was touted as an "airline" railroad—that is, one that would have the shortest distance between its two endpoints. The chief proponent of this grand scheme was Dewitt C. Littlejohn, who wished to connect his beloved Oswego, a port on Lake Ontario, with the great transportation crossroads centered in and near the New York harbor.

The Midland, as it came to be known, was born of necessity to improve, develop, and open up the interior reaches of New York State. Despite these well-intentioned plans to bring prosperity to central New York, the Midland's route was ill conceived and, because of its abuse of town bonding laws, was not to be a financially solvent line. By the early 1870s, the line had sunk into the depths of receivership.

Much hope remained for a line with so much promise because of the tremendous Great Lake commerce arriving at Oswego, the closest port to the New York harbor; its route along the north shore of Oneida Lake, where tourist communities could certainly be developed; a connection with the Albany & Susquehanna Railroad (a Delaware & Hudson Canal Company property) at Sidney Plains, where coal could be interchanged with the cross-state railroad; and the beauty of the line skirting the southern Catskill Mountain range, which would certainly attract excursionists—the railroad providing their transportation. The Midland was indeed a railroad with much promise, but its potential was never achieved during its original incarnation. That was reserved for the party of purchasers who ended the Midland's receivership by acquiring the line in November 1879. The new name for the old Midland became the New York, Ontario & Western Railway. Speculation and hopes both ran high for the future of the O & W.

The O & W met with a degree of success during its operation of the old Midland. It was able to make its on-line communities prosper and, in turn, the mostly small villages provided a modicum of business to help support the railroad. Unfortunately, the route of the O & W

did not include any large industry that could financially offset the mom-and-pop businesses that were the mainstay of the road's car loadings. The opening of a branch line that tapped the Lackawanna Valley (Pennsylvania) coal fields in 1890 finally turned the O & W into a financially stable line. Adding to its financial stability was a thriving passenger line to the Catskills' recreational resorts, a similar seasonal trade with an Oneida Lake terminus at Sylvan Beach, and an ever-increasing network of milk collection points and milk trains that thrust the O & W into the role of top milk supplier to Gotham.

While the New York, Ontario & Western was quite successful in building the railroad into an important forwarder of traffic between the lake and the harbor, its success was short lived. By the 1920s, the effects of encroaching automobile, bus, and truck traffic made deep inroads into the line's profitability, and by the following decade, the line fell into receivership, eventually becoming the first Class One railroad to be abandoned, on March 29, 1957.

The passing of the O & W, and the Midland before it, left an indelible mark on the communities the railroad once served. Because it was never able to compete with the mighty New York Central Railroad—a position the Midland had thought attainable—it was forever a second-rate railroad, an underdog. However, because many Americans seem to favor an underdog, the railroad largely had, and still has, the approval of those living along its line.

Charm was something the New York, Ontario & Western Railway had in abundance, especially in central New York. On the O & W's Northern Division situated between Oswego (the northern boundary) and Sidney (the southern)—the heart of central New York and the geographic emphasis of this book—small wood-frame depots connected the railroad and the communities it serviced, largely by short freight and passenger trains powered by the line's smaller motive power. In this region, the service was personal, and because of the hilly route built by the Midland, train speeds held mostly to a lazy 30 miles per hour. The single-track cinder roadbed, numerous trestles, and agents with years of service at their depots were all important elements in the O & W's quintessential charm.

The railroad served the communities between Oswego and Sidney until time and technology passed it by. The villages and their people forsook the railroad for the highway, but the O & W is fondly remembered today. This book will help to preserve the memory of the New York, Ontario & Western Railway, while helping to remind central New Yorkers of their once proud, prosperous, and personable railroad.

One

THE TRAINS WE RODE

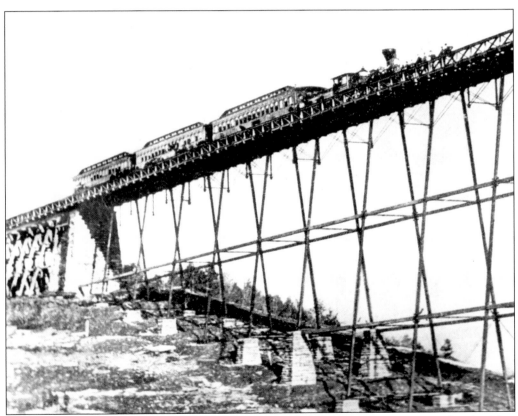

The construction of the Lyon Brook Bridge was a defining engineering event for the New York & Oswego Midland Railroad on its line north of Sidney. Not long after the bridge was completed in 1869, locomotive No. 4, named the *Delaware*, tiptoed onto the structure with its three-coach train. This engineering wonder was located between Norwich and Oxford. (Courtesy Ontario & Western Railway Historical Society.)

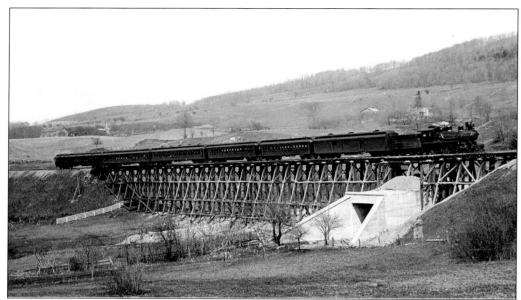

Railroading in the Stockbridge Valley (south of Oneida) was highlighted by the daily passing of train No. 6. Seen here crossing one of the many wooden trestles built by the Midland, the Atlantic Express provided overnight service for passengers traveling between Chicago and New York via a Wabash, Rome, Watertown & Ogdensburg, and Ontario & Western railroad routing. (Photograph by Floyd Davenport, courtesy Bruce Tracy.)

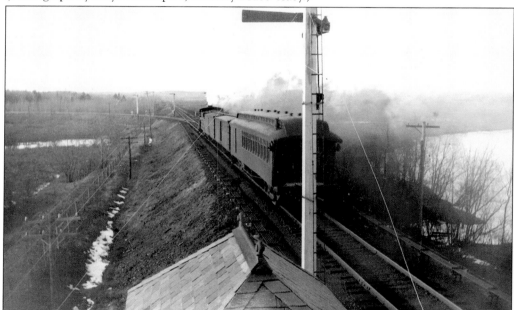

A network of milk trains propelled the O & W into the forefront of fluid milk delivery to New York City; a coach was added to provide some degree of passenger accommodation. Milk train No. 9 heads north at Sylvan Junction with a combination car bringing up the markers. The switch for the Sylvan Beach Loop is dead ahead. Towerman Leo Mengel photographed the scene from an SX tower window. (Author's collection.)

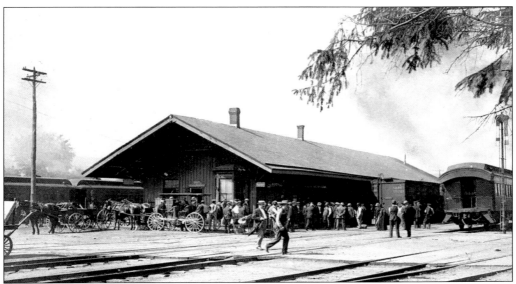

The O & W's Northern Division began at the large wooden board-and-batten station (above) shared with the Delaware & Hudson Railroad at Sidney. The D & H main line between Albany and Binghamton passed the north side of the depot (above, right) while the O & W's trackage was on the south side. While all of the Ontario & Western's passenger trains called at the Sidney Union Station, only the New Berlin Branch trains originated and terminated there. Sometime during the summer of 1904, O & W engineer John Fagan poses with his locomotive (below) at Sidney before beginning his run to New Berlin and Edmeston via the branch. In the distance is the railroad's original freight house. (Both photographs courtesy Sam Reeder.)

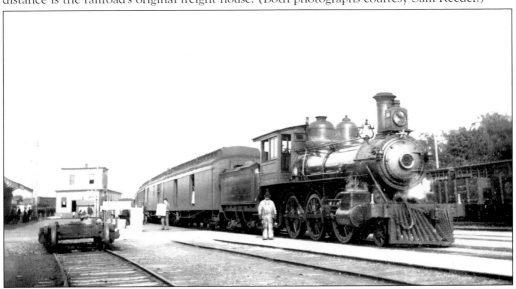

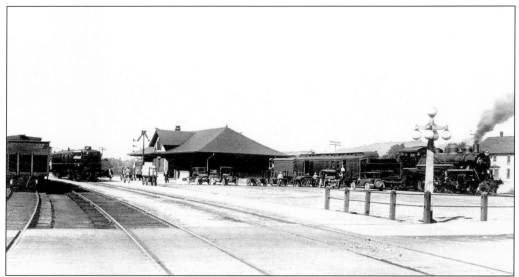

A new union station (above) was built at Sidney in 1913, and in the late 1920s, it is shown surrounded by a conventional D & H steam-powered passenger train bound for Albany and the O & W's new Brill-built gas-electric car No. 804, running as the Delhi Flyer. Although both trains are operating in the same direction, the D & H train is considered northbound, while the Flyer is southbound. A closeup of No. 804 (below), also at Sidney, reveals that the car was equipped with baggage and railway post office rooms, as well as the standard passenger and crew compartments, making it the only car (of three) so equipped. The Delhi Flyer ran between Utica and Delhi, New York. Today's conductor is Percy Spring, who is standing in front of the baggage room door. (Courtesy Clyde Conrow and Jack W. Farrell.)

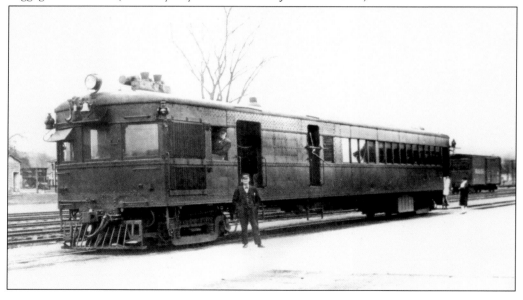

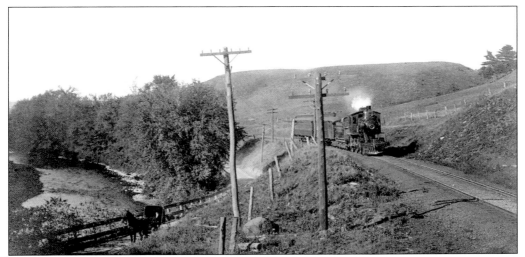

Viewing the passing countryside was a visual delight while riding the Ontario & Western's passenger trains. Enjoying the beautiful Unadilla River from a coach of a New Berlin Branch train at the Dugway (north of Sidney) provided fond memories for all passengers who witnessed the scene. (Courtesy Clyde Conrow.)

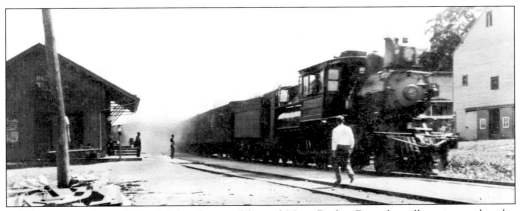

While passing through Rockdale, the northbound New Berlin Branch milk train rattles the depot rafters as it roars through town bound for Edmeston. Whether delivering empty milk cans or picking up milk-laden cans at the milk stations, the O & W expedited its trains in order to satisfy the consumer as well as the dairy farmer. (Courtesy Bruce Tracy.)

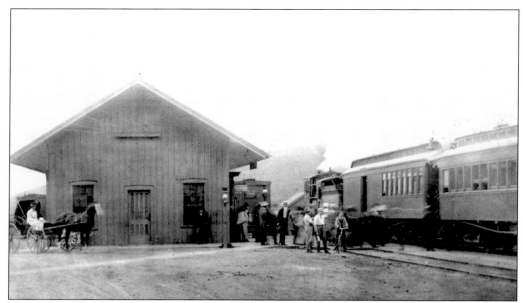

It was an everyday ritual to meet the train at the Mount Upton depot. In this view, passengers arrive and depart while observers and gossips look on. The New Berlin Branch train has just arrived from Edmeston; two short whistle blasts will announce its departure for Sidney. (Courtesy Bruce Tracy.)

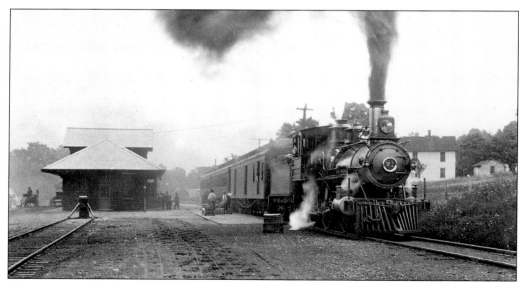

The engineer of the northbound Utica Flyer has brought train No. 13 to a stop at the Guilford station. While baggage and mail are being handled, the fireman is building up a good head of steam. That steam will soon be put to good use once the train is started on the heavy grade leading to Summit. Engine No. 71 held down this run for many years. (Courtesy Bruce Tracy.)

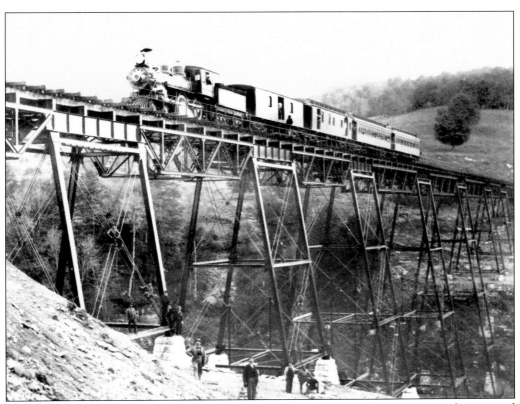

The Ontario & Western's passengers were afforded an uninterrupted scenic view as they crossed the lofty height of the Lyon Brook Bridge. Bridge No. 282, as it was officially known by the railroad, got its name because it spanned the gorge of the Lyon Brook some 170 feet below. Not long after the original spindly bridge was rebuilt in 1894, a northbound accommodation train is stopped on the bridge (above). This may represent an official's inspection of the bridge, as "admirers" are gathered on the trestle walkway as well as on the ground below. Giving a somewhat better perspective of the bridge's 820-foot length, southbound milk train No. 10 soars across the bridge (below) with at least eight milk cars and an out-of-sight coach in tow. (Courtesy Jack W. Farrell and Bruce Tracy.)

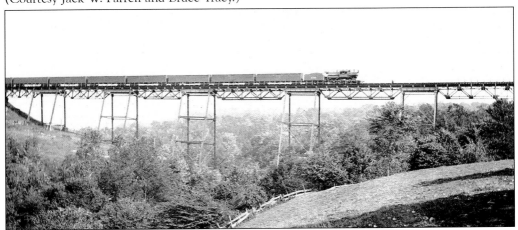

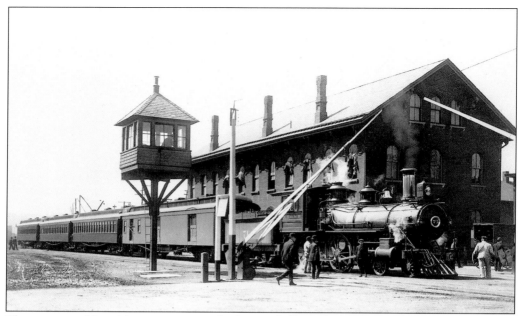

The two-story Norwich station was at the heart of all Northern Division operations, and here provides the backdrop for the Utica and Delhi Flyers (trains No. 13 and No. 14) in transition. The Flyers operated between the Delaware county seat of Delhi and the Oneida County seat of Utica. The Brooks-built No. 71 (above) has brought its conventionally equipped steam train (No. 13) to a stop at the station. In order for the railroad to minimize its passenger train losses, it purchased in 1926 Brill-built railcar No. 804 which replaced the old steam cars and operated between the two county seats as trains No. 55 and No. 56. The No. 804 (below), working in that capacity, makes its station stop in Norwich. In both scenes, the O & W's crossing tower protects the railroad's crossing of East Main Street. (Both photographs courtesy Bruce Tracy.)

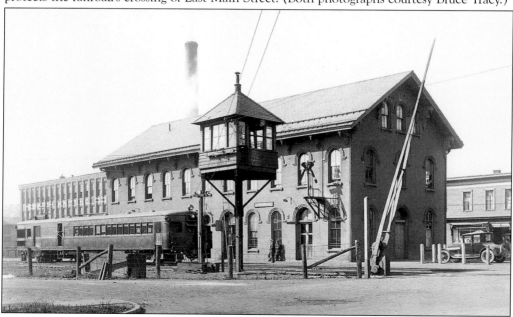

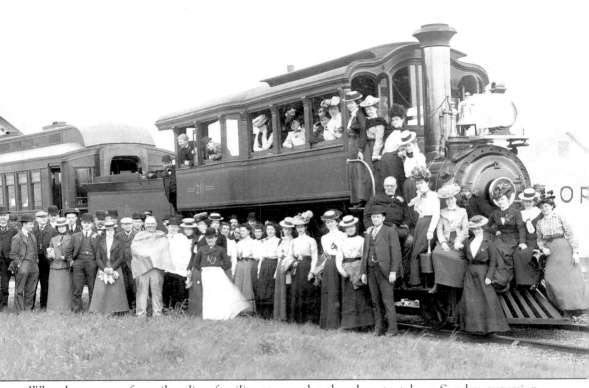

What better way for railroading families to spend a day than to take a Sunday excursion on their railroad. Here, men and women from Middletown have donned their Sunday best, boarded car No. 25, and headed off for Norwich, where they are seen decorating inspection engine No. 26 on the Borden Condensary siding. No. 26, here with its early cab, was generally used all over the O & W system whenever an official called for its transportation services, but it was also used to transport excursionists. Northern Division superintendent William C. Hartigan, whose office was in the two-story station in Norwich, is standing at the extreme left. (Courtesy Sam Reeder.)

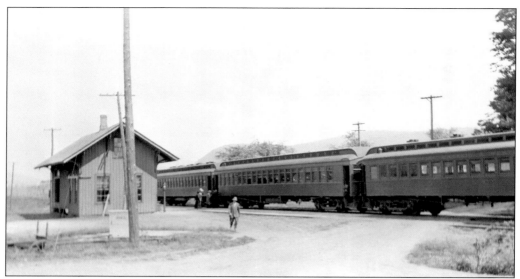

Residents of North Norwich had double the railroad pleasure because their O & W depot was only a stone's throw from their Delaware, Lackawanna & Western Railroad depot. The pleasure of having trains from two railroads serve the community was only diminished by the O & W changing its station name here to Galena in 1897. The Lackawanna followed suit, but the passenger trains nonetheless continued stopping at the two Galena depots in North Norwich. The view above of an O & W train at their Galena depot was taken from the Lackawanna's Galena depot. The view below depicts the Lackawanna depot from the Ontario & Western station. An enterprising photographer took both pictures in the summer of 1918. (Both photographs courtesy North Norwich historian Jan Decker.)

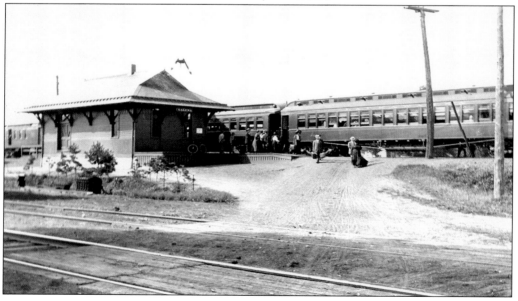

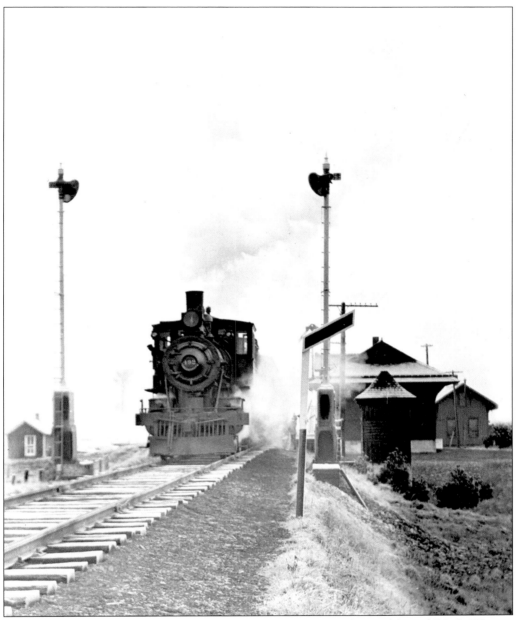

Much of Galena's railroad "scene" is captured in this picture of a southbound DL & W train getting under way for its next stop at Norwich. The lower quadrant signals are awaiting their blades; the architecture of the new DL & W depot contrasts sharply with O & W's board-and-batten and gable-roofed station; and a conical roofed "water-closet" awaits its next user. The men building the new highway overpass just south of the village used the small shack at the far left for their office. Steam railroading and country depots were both important components of this bygone era. (Courtesy North Norwich historian Jan Decker.)

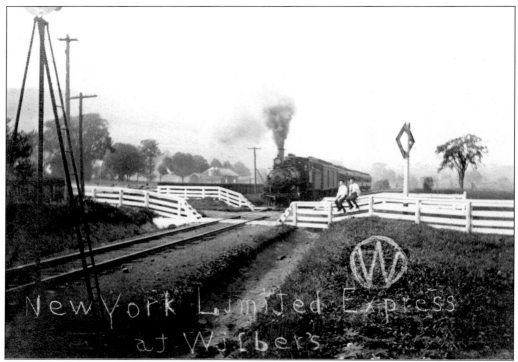

The New York Limited was a popular subject for photographers because it traveled over the Northern Division during daylight hours. A five-car train, No. 6, is about to pass the Wilbers train order office, near Smyrna. The two gents on the fence seem more interested in the photographer than in the speeding train. (Courtesy Bruce Tracy.)

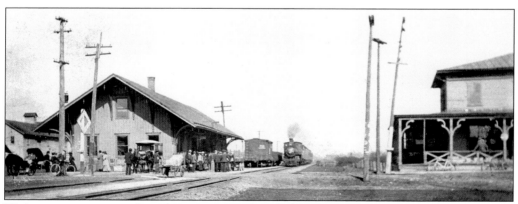

With an impressive number of passengers on the platform, train No. 6 is about to make its stop at the Earlville depot to board these paying customers. Both the depot (left) and the Riverside Hotel (right) catered to the needs of the traveling public. (Courtesy Bruce Tracy.)

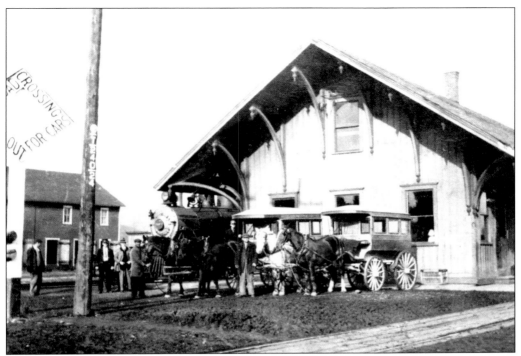

A closeup view of the south end of the O & W's Earlville depot shows omnibuses waiting to transport passengers to downtown Earlville. Also pictured are the attractive eave supports that adorned the building, as well as a locomotive that has just brought a trainload of passengers from Syracuse via the New York Central's West Shore Branch. The O & W track is at the lower right. (Author's collection.)

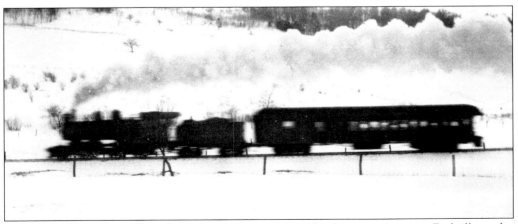

A one-car West Shore Branch train traverses a wintry landscape as it nears Earlville and a connection with an Ontario & Western train. This line was originally surveyed by the New York & Oswego Midland Railroad but was built as the Syracuse & Chenango Valley Railroad in 1872. (Author's collection.)

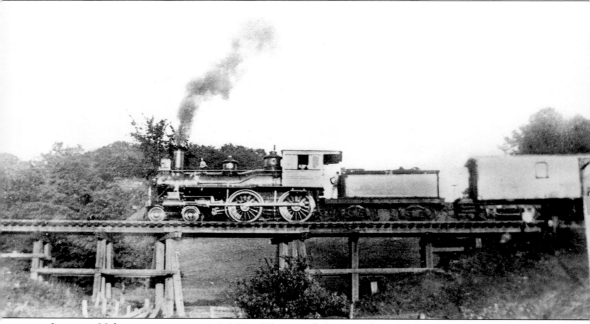

In a pre-20th-century scene, 4-4-0 No. 75, named the *Hamilton*, leads a late-day Pacific Express over bridge No. 328 just north of Eaton station. The *Hamilton* was one of the 54 American-type locomotives built for the New York & Oswego Midland Railroad that were transferred to O & W ownership in 1879. (Courtesy Sam Reeder.)

Whether summer or winter, milk train or long distance train, the Ontario & Western's riders were afforded breathtaking views while passing through the scenic Stockbridge Valley. In these two views of milk train No. 10 (above) and train No. 6 (below), the community of Munnsville lies deep within the valley, several hundred feet below the O & W's right-of-way. The track was located here so the Midland could cross the valleys rather than run within them. This routing would forever cause gradient problems for the Midland itself and its successor, the O & W. (Both photographs by Charles Stringer, courtesy Sam Reeder.)

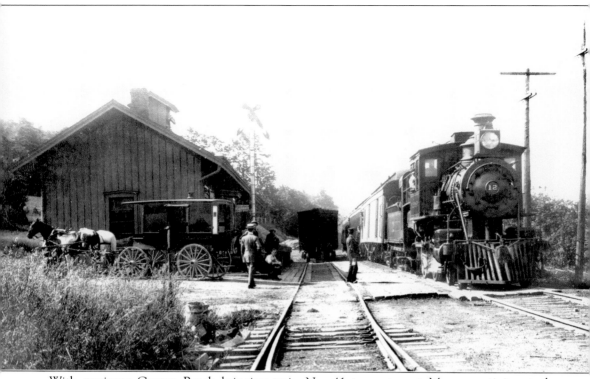

With engineer George Brock bringing train No. 41 to a stop at Munns, activity at the depot is heightened. Agent Perry Pindar assists passengers, telegraph operator Ed Dixon will present telegraphic orders to the train crew, the Weller omnibus stands ready to transport any passengers needing to go down to the village of Munnsville, and a mail clerk is ready to receive and dispatch the U.S. mail. No. 41 was a jack-of-all-trades train that ran between Norwich and Oswego, providing timely service to the communities along its route. In 1893, the O & W changed the name of its Munnsville depot to simply Munns, thereby lessening the telegraphic and written confusion of Munnsville and Morrisville, a railroad community to the south. (Courtesy Sam Reeder.)

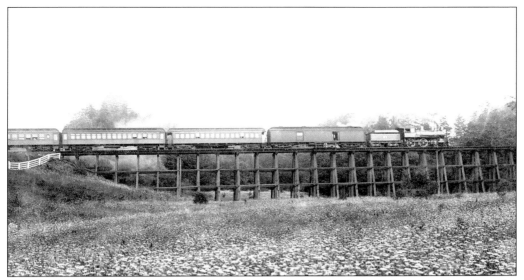

The Stockbridge Valley, train No. 42, and long wooden trestles together contributed to the unique charm of the Ontario & Western Railway. Southbound No. 42, with engine No. 71 in charge, flies over the Stockbridge Trestle on its Oswego-to-Norwich flight. (Photograph by Floyd Davenport, courtesy Sam Reeder.)

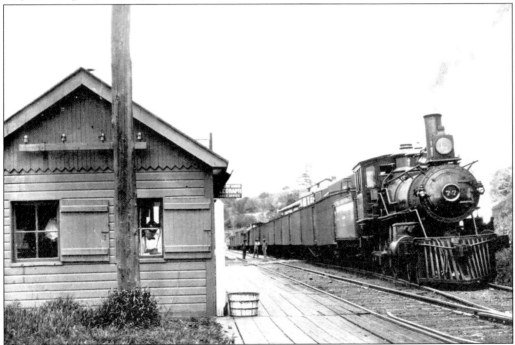

At the head end of milk train No. 10, engine No. 77 simmers while milk cans are loaded from the Valley Mills milk station. Through the depot window we see agent Art Peck hard at work preparing train orders that will give No. 10 the road to Munnsville. The original depot here burned in 1893, replaced simply by this little trunk of a building shortly thereafter. (Photograph by Charles Stringer, courtesy Sam Reeder.)

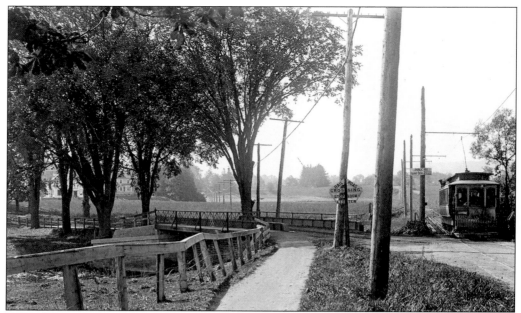

Some Ontario & Western passengers could either start or end their journey by using connecting trolley lines. At Kenwood, the home of the Oneida Community Silversmiths, the one-car Sherrill-Kenwood Trolley had a stop directly across from the O & W station. From that point, the trolley (above) could whisk passengers to either the main plant or knife plant of the company through a mostly residential routing. At the jointly operated Oneida Castle station (below), O & W passengers could transfer to and from the speedy trolley cars of the New York State Railways to get to Utica or Syracuse. Oneida Castle was a major transfer point during the summer season for those who wanted to go to Sylvan Beach via the O & W. (Courtesy Laura Clark and Bruce Tracy.)

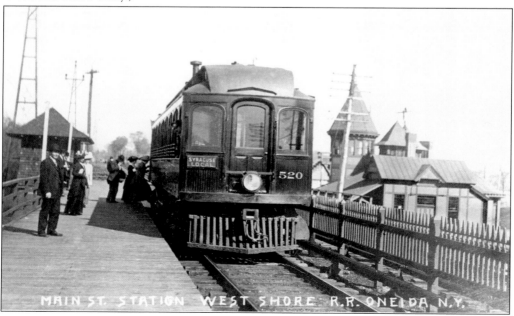

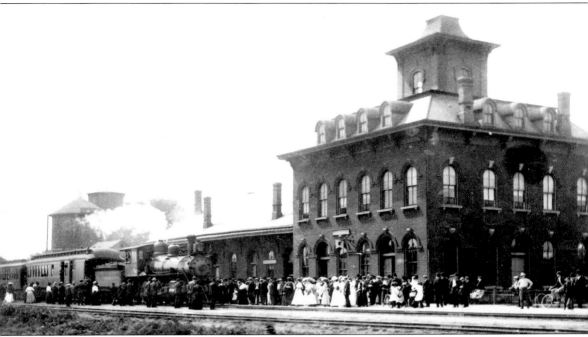

Passengers witness the arrival of a Sylvan Beach–bound local train at the Oneida station. Every summer season, the Ontario & Western ran extra trains between Oneida Castle and Sylvan Beach to accommodate the throngs of tourists bound for that Oneida Lake resort known simply as "the Beach." This may be the day of the hop growers' picnic—the largest such affair held yearly at the beach. The Oneida station, built by the Oswego Midland and opened to the public in August 1873, is among the most architecturally pleasing of all stations erected by the Midland. Besides the essential ticket office, waiting rooms, and toilets for both men and women, the grand station also provided room for railroad personnel offices on the upper floor and a restaurant in the attached gable-roofed building. This station, closed in 1939, saw many passengers off to Sylvan Beach and other distant locations. (Courtesy Walt Kierzkowski.)

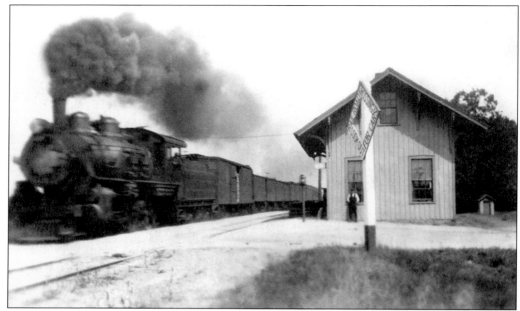

A W-class Consolidation leads milk train No. 14 past the board-and-batten depot at Fish Creek sometime in 1920. In earlier years, Fish Creek station was the jumping-off point for Oneida Lake tourists until the Sylvan Beach Loop was constructed and put into service in 1886. (Author's collection.)

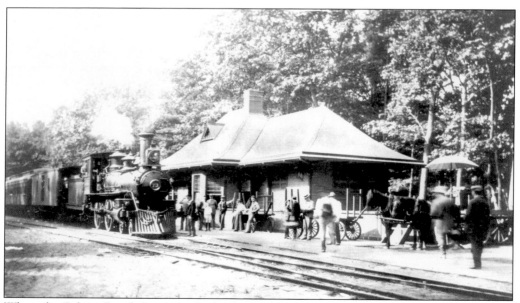

When the Sylvan Beach Loop was built, O & W trains could deliver their passengers directly to the water's edge. The original Sylvan Beach depot was replaced by this attractive station in 1893. It appears that the local train is preparing to return to Oneida Castle for another load of Oneida Lake tourists. (Courtesy Jack W. Farrell.)

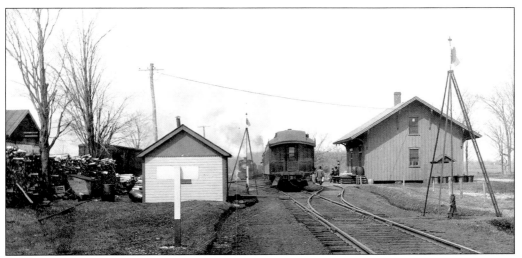

It is midmorning in Constantia as train No. 41 makes its stop at the depot. In the distance, southbound train No. 14 is safely tucked into the siding to allow No. 41 to pass. The high switchstand targets were designed for visibility in the winter when snow began to pile high on the north shore of Oneida Lake. (Courtesy Bruce Tracy.)

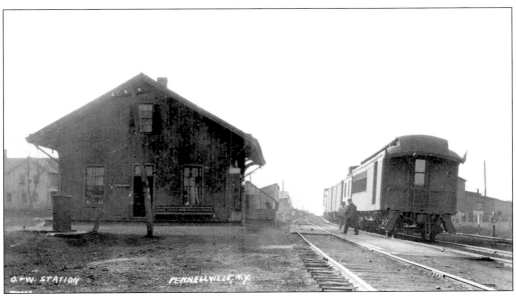

Northbound train No. 13 arrives at the O & W's Pennellville depot; its combination car carries passengers who do not mind riding the makes-all-stops milk train. The absence of activity at the depot was the main reason most of the O & W's Northern Division passenger service became extinct in 1929. (Courtesy Bruce Tracy.)

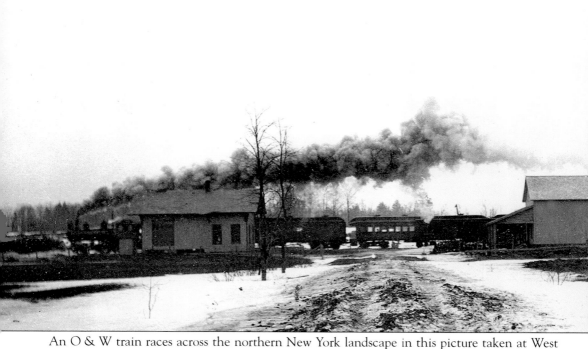

An O & W train races across the northern New York landscape in this picture taken at West Monroe during the early 20th century. Depicted is a late-running Chicago Express passing the West Monroe Cooperative Dairy (right) and the tiny 20- by 40-foot depot (left), leaving a plume of exhaust smoke in its wake. The appropriately named Depot Street bisects this scene that looks north. (Courtesy Bruce Tracy.)

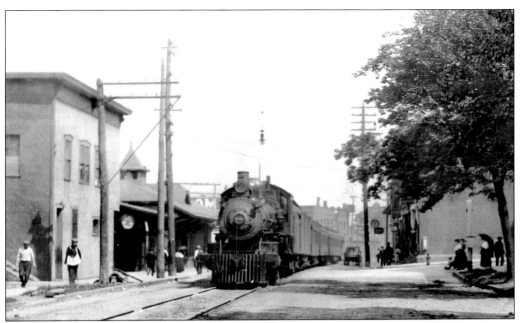

When the Oswego Midland completed their railroad between Fulton and Oswego, the Rome, Watertown & Ogdensburg Railroad (later a part of the New York Central Railroad) was given permission to operate passenger trains over the route. That is why this New York Central train is seen passing the O & W's Fulton depot en route to Syracuse. (Courtesy Bruce Tracy.)

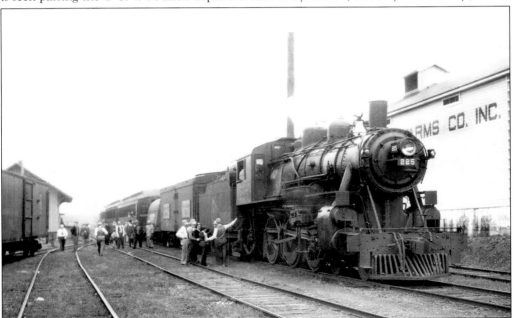

On April 20, 1941, the Railroadians of America rode milk train No. 10 to go on an Ontario & Western excursion to Norwich. At Eaton, E-class 4-6-0 No. 225 has stopped the train so that the excursionists can inspect the depot (left) and the Sheffield Farms Company creamery (right). No. 225 might get examined as well. (Photograph by Paul Prescott, author's collection.)

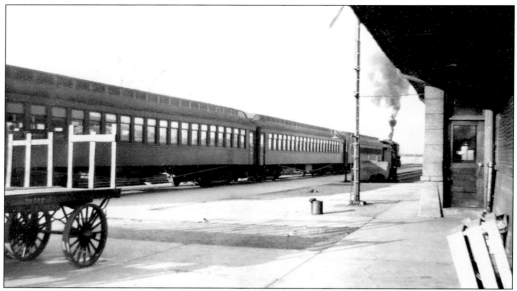

For several years during World War II, the O & W teamed up with the federal government to run special employee trains from Norwich to Sidney for workers at the Scintilla-Bendix Magneto factory. In its own way, the O & W helped to bring the war to a successful conclusion. This is the wartime train leaving Sidney Union Station. (Courtesy Clyde Conrow.)

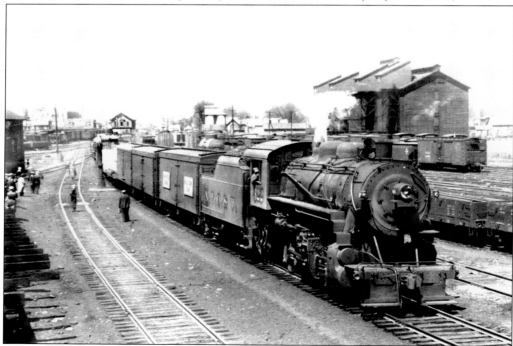

The last vestige of passenger service on the Northern Division was the lone coach attached to the tail end of milk trains No. 9 and No. 10. By the late 1940s, both the milk train and coach had made their last run. In happier days, 2-8-0 No. 322 leads No. 10 through the Norwich yard with milk for the metropolis. (Courtesy Walt Kierzkowski.)

Two

MANIFEST FREIGHTS

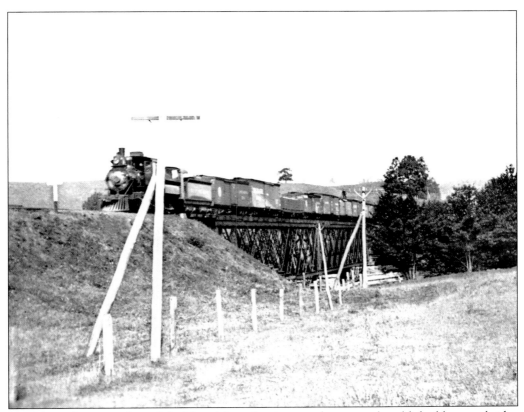

Northbound tonnage bound for Norwich and points north crosses the old double-span bridge over the Unadilla River just north of Sidney. The stiff grade to Summit, the divide between the Unadilla Valley and Chenango Valley watersheds, lies dead ahead. (Courtesy Sam Reeder.)

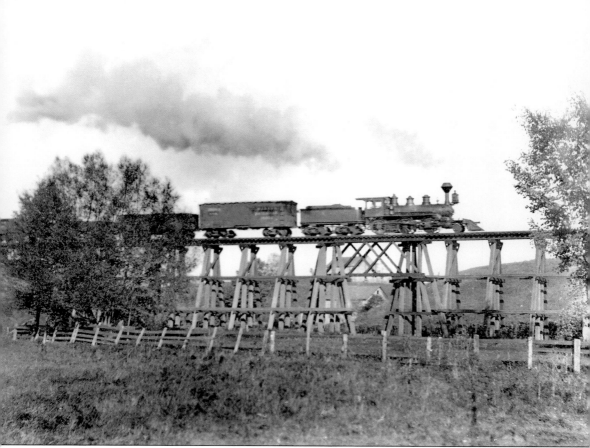

When the Oswego Midland was building its railroad in 1868–1869, it constructed many wooden trestles to level off the terrain. Rather than fill in the areas that had to be bridged, trestles were erected to speed the completion of the railroad. Once the road was in operation, the trestles could be filled in to make earthen embankments. One such Hemlock trestle, over the Oneida Creek near Kenwood, supports the passing of a northbound merchandise train with an early Mogul-type locomotive for its power. (Photograph by L. Virgil Lewis, courtesy Bob Morris.)

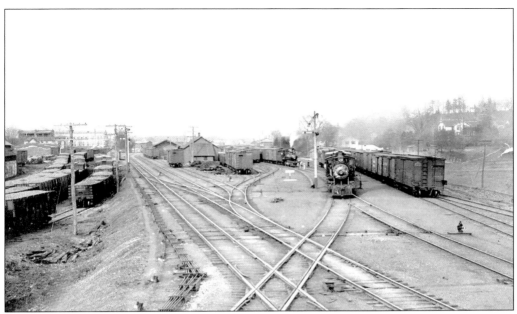

All northbound trains leaving Sidney headed out onto the Northern Division by crossing at grade the double-track main line of the Delaware & Hudson Railroad. Protecting the crossing of the two railroads was GX tower, where levers were used to set signals and manipulate switches to effect a safe path for each train. In a view taken from the tower (above), an O & W train is about to cross the D & H, while from ground level (below), GX tower is about to witness a similar train heading north over the D & H double track. (Courtesy Clyde Conrow and Sam Reeder.)

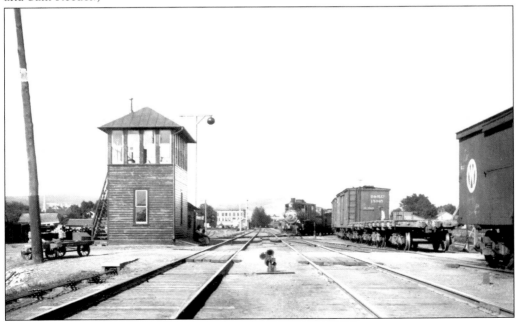

There were five severe grades on the Northern Division that required the use of helper locomotives on most freight trains: traveling both directions to Summit, both directions to Eaton Summit, and over a short northbound grade at Smyrna. Representative of the railroad's operation on these districts is this breathtaking scene taken near Parker. Depicted is train No. 29, a 25-car Ontario Central Despatch being led by an I-class 2-6-0 and pushed by 2-8-0 No. 91 with Archer Weeden at the throttle. It took the full effort of these two locomotives to gain the 618-foot change in elevation between Sidney and Summit. (Courtesy Norma Palmer.)

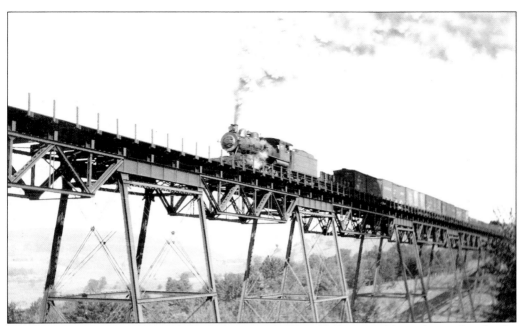

Crossing the rebuilt Lyon Brook Bridge at Haynes, New York, a southbound manifest freight works its way upgrade from Norwich to Summit. (Courtesy Bruce Tracy.)

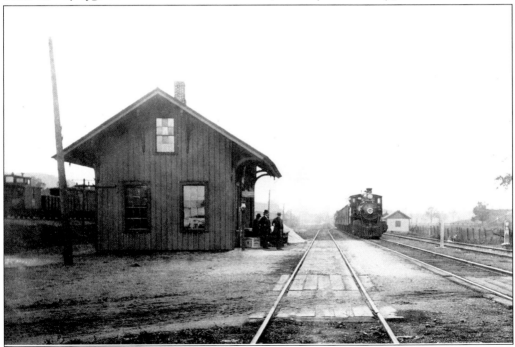

Train time at Galena finds a handful of people waiting for the next passenger train. In the meantime, they can watch an empty southbound coal train (right) make its stop short of the highway crossing. A Lackawanna train sneaks by northward to the left. (Courtesy Chenango County Historical Society.)

For quite a few miles between Oxford and Sherburne Four Corners, the tracks of the Ontario & Western and the Lackawanna Railroads share the Chenango River valley. The two railroads come very close together at the Lyon Brook Bridge, although still separated by a half-mile. The two lines are even closer at Galena, where they are a mere 50 feet apart. South of Norwich, a

northbound DL & W train follows its camelback locomotive into town, and in the distance a southbound O & W train starts its ascent to the Lyon Brook Bridge and Summit. Between them flows the Chenango River. (Courtesy Bruce Tracy.)

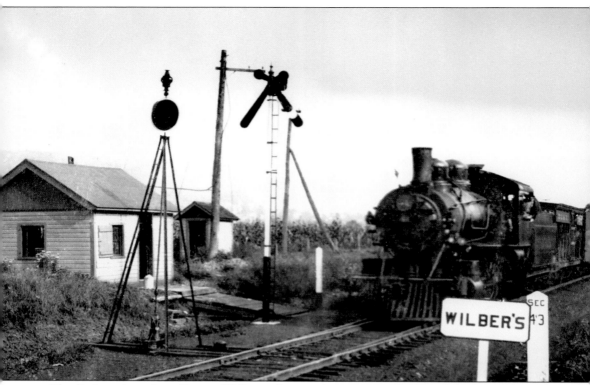

The little train order office at Wilbers, along with its train order board, high switch target, section marker, and outhouse stand mute to the thunderous passage of the northbound Ontario Central Despatch. The purpose of this rural office was to facilitate the operation of trains over Smyrna Hill and to provide train order protection for all trains using the 91-car passing siding located there. After 1916, the services of the Wilbers train order office were deemed unnecessary and it was closed. (Courtesy Clyde Conrow.)

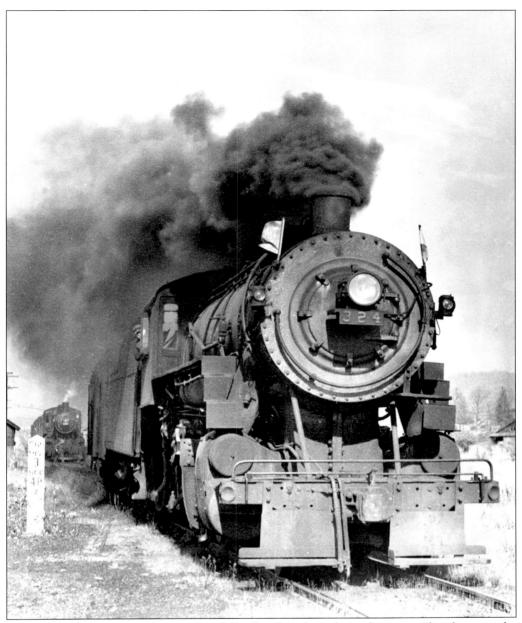

Because of this picture taken at Randallsville, the glory days of steam railroading on the O & W can be best remembered. Depicted is engineer Jim Byrne widening out on the throttle of W-class No. 324 leading a Norwich-bound freight off the Utica Division, while in the distance E-class 4-6-0 No. 225 with train No. 10 waits at the depot to continue its trip to Norwich. Randallsville was an important junction where the O & W main line to Oswego and the Utica Division to Utica and Rome diverged. Engineer Byrne was also the postmaster of Norwich at the time of this photograph in 1940. (Photograph by Henry Harter, courtesy Joan Prindle.)

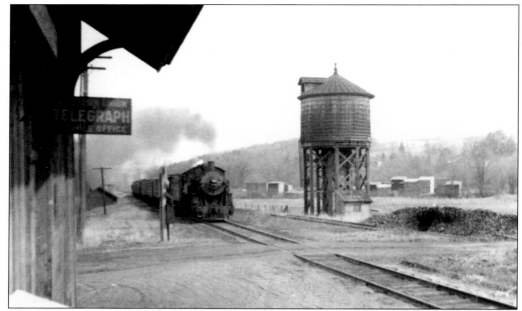

Manifest freight train AW-2 cruises through Smyrna; also pictured are a uniquely styled O & W water tank (right) and depot (left). Trains AW-2 and WA-1 were run every day between Arrowhead (Fulton), New York, and Weehawken, New Jersey. (Courtesy Chenango County Historical Society.)

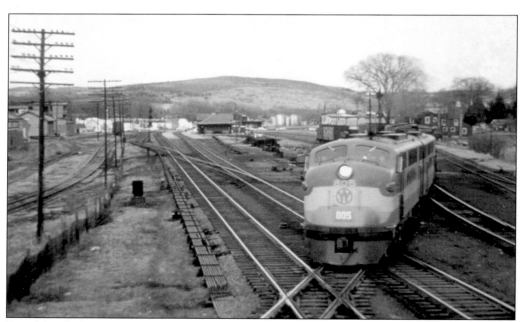

Diesel freight locomotives came to the O & W beginning in 1945 and were hoped to be the "Old & Weary's" salvation. Nevertheless, in 1957, FT No. 805 crosses the D & H at Sidney on what might be its final northbound run before the March 29, 1957 abandonment of the railroad. You may wish to compare this scene with the one on page 35. (Courtesy Sam Reeder.)

Three

STATIONHOUSES AND STRUCTURES

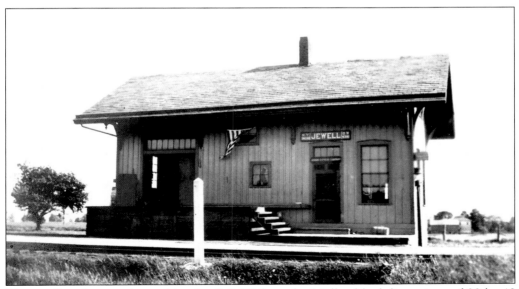

The smallest depots inherited by the O & W from the Midland had dimensions of 20 by 40 feet, with at least 11 examples having been built. Jewell was unique because of its basement apartment for long-term agent Clinton H. Drum. In this 1914 view, the American flag is flying in honor of Memorial Day. (Photograph by Esther Bellamy, courtesy Ken Bryant.)

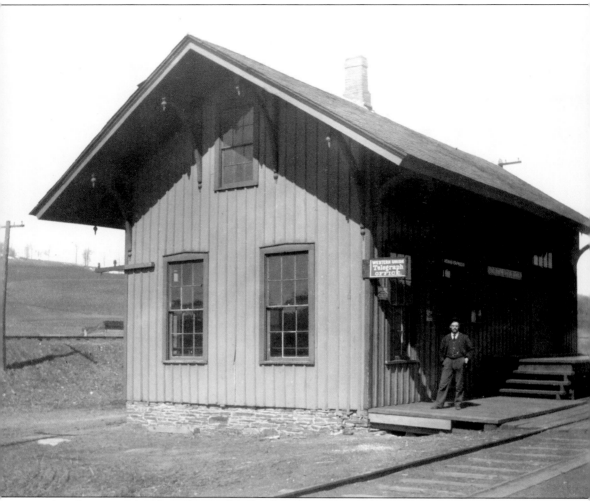

Another example of an Oswego Midland–built 20- by 40-foot depot was at North Norwich, where Howard L. Brooks was the agent when this 1897 photograph was taken. When the Delaware, Lackawanna & Western Railroad was built parallel to the O & W here, they erected a similar structure (at the top of the next page) to serve the community. (Courtesy North Norwich historian Jan Decker.)

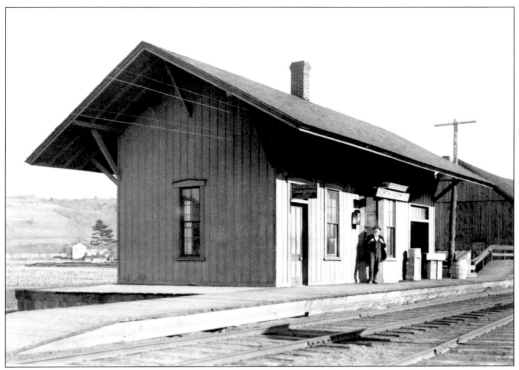

The Lackawanna agent in 1897 was Willis C. Lindsay (above, by the bay window). The DL & W built a new depot (below) to serve Galena (North Norwich) after the original met its demise by fire. The O & W station was closed and, in 1947, was sold for $100. (Both photographs courtesy North Norwich historian Jan Decker.)

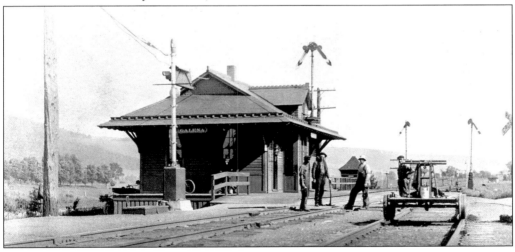

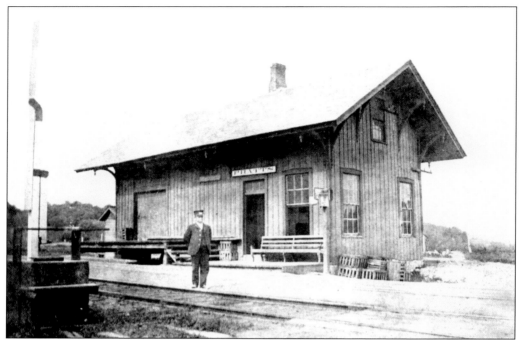

In the Stockbridge Valley, the community of Pratts Hollow had its own small depot (above) that the railroad called simply Pratts. In this pre-20th-century scene, Jay B. Marshall stands in front of the depot where he was the agent for 32 years. Although small in size, the West Monroe depot (below) contains all the trademarks of an Oswego Midland–built station. The characteristics were an uninterrupted gable roof, eave supports with bottom-mounted finials, upper-story windows, transoms above the doors, and board-and-batten sheathing. (Courtesy Sam Reeder and Bruce Tracy.)

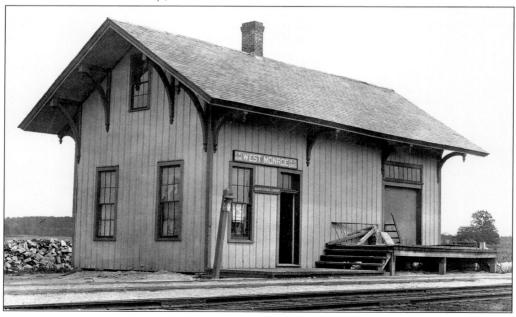

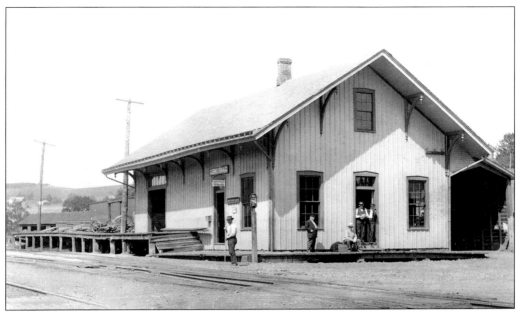

All Oswego Midland–built depots lacked a bay window, resulting in a rather flat-faced appearance. Consequently, their plainness was their charm. The O & W depots at Smyrna (above) and Kenwood (below) were both 30 by 50 feet in size. Both buildings have covered scales attached; second-story living accommodations have been added to Kenwood. (Courtesy Bruce Tracy and author's collection.)

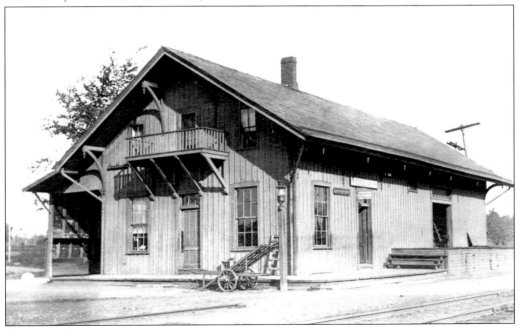

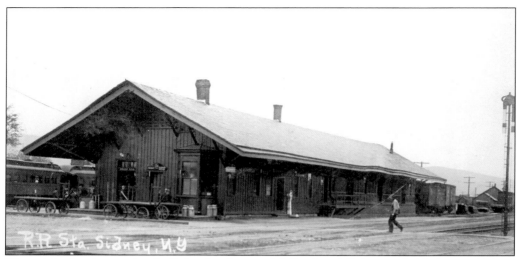

The original union station built by the Oswego Midland and Delaware & Hudson at Sidney (above) was the largest board-and-batten depot along the line of the O & W. It was replaced in 1913 by a more modern, albeit smaller, brick-and-stone station (below) that cost $9,585.42 to build. Other Northern Division union stations were at Earlville, Oneida Castle, and Central Square. (Courtesy Clyde Conrow and Ontario & Western Railway Historical Society.)

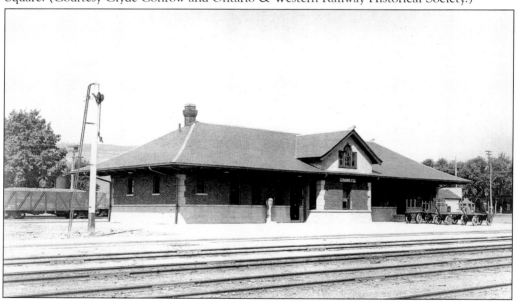

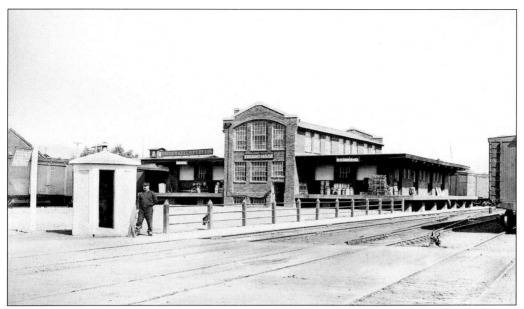

Not only did Sidney get a new union station in 1913, it also received a new union freight house. Less-than-carload freight could be handled by the D & H (left) and the O & W (right). Both railroads shared the $6,929.11 cost. Crossingman Mott Videtto guards the Main Street crossing in the foreground. (Courtesy Ontario & Western Railway Historical Society.)

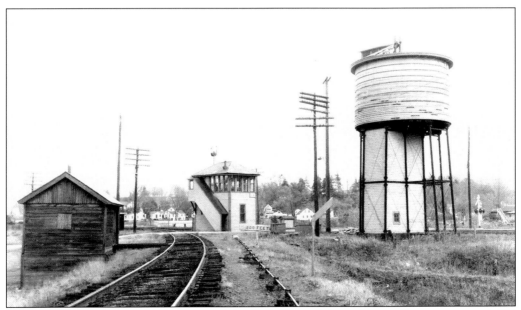

Just north of the O & W's crossing of the D & H in Sidney, Union Street separated GX tower and a D & H water tank. To the left is the first Northern Division sectionmen's shanty. (Courtesy Ontario & Western Railway Historical Society.)

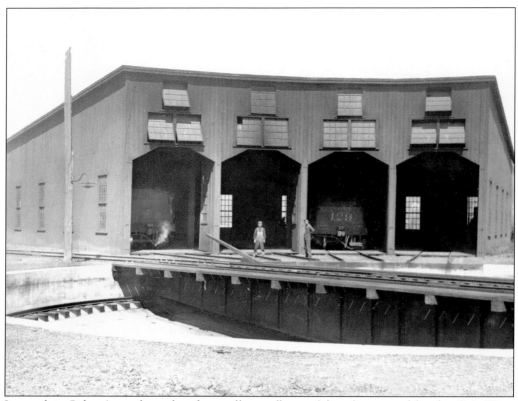

Located in Sidney's south yard, a four-stall roundhouse (above) was used by the O & W to service their steam locomotives between runs. It was not unusual for roundhouses to succumb to fire, and when this one did, a one-stall enginehouse similar to the one at Oneida (below) was erected. Oneida's original roundhouse burned to the ground as well. (Courtesy Ontario & Western Railway Historical Society and author's collection.)

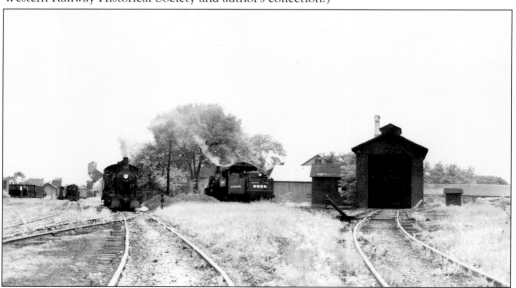

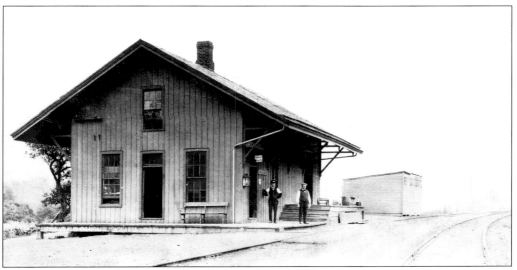

Looking south at Rockdale, the O & W depot, agent, and telegraph operator pose for a picture on a hot summer day. Opened doors and windows provided ventilation in the days before air conditioning. (Courtesy Bruce Tracy.)

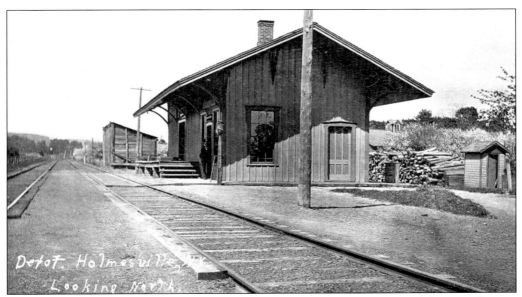

Depot. Holmesville, NY
Looking North.

Even though the New Berlin Branch depots were built by the Midland, they did not conform to the same standard design as the main-line stations. Holmesville is an example of the difference in architectural styles. Whether on the main line or branch, however, all country depots lacked toilet facilities, hence the water closet (outhouse) to the right. (Courtesy Bruce Tracy.)

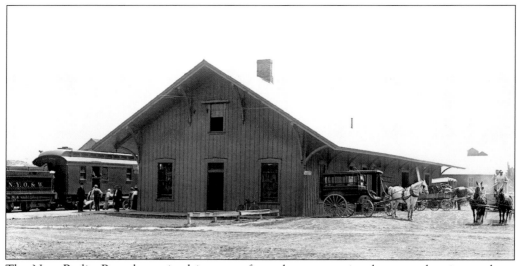

The New Berlin Branch received its name from the community that served as its northern terminus. Because of the business received by the railroad at that location, the village of New Berlin received the largest (35 by 120 feet) board-and-batten depot built solely by the Oswego Midland. The station remains standing today. (Courtesy Bruce Tracy.)

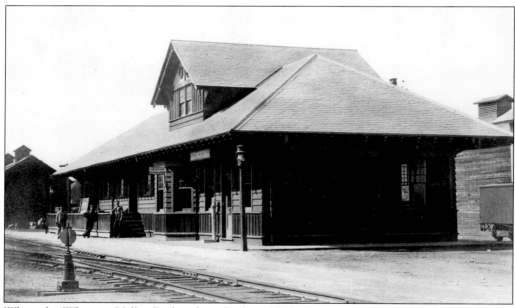

When the Wharton Valley Railroad was built in 1889, the new road extended the New Berlin Branch from New Berlin to Edmeston. This modern depot at Edmeston replaced the original station 21 years later and was a mirror image of the new station at Guilford. O & W logos under the gabled peak eaves advertised the building's owner. (Courtesy Bruce Tracy.)

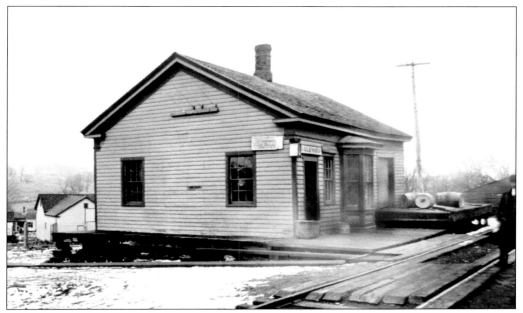

The village of Guilford was the only location along the line of the newly completed NY & OM Railroad where a depot was not built. Instead, district school No. 14 was acquired and fitted for railroad purposes. The O & W used this schoolhouse depot until a new station was built (at a cost of $2,730.56) and opened to the public on September 22, 1904. (Courtesy Town of Guilford historian Tom Gray.)

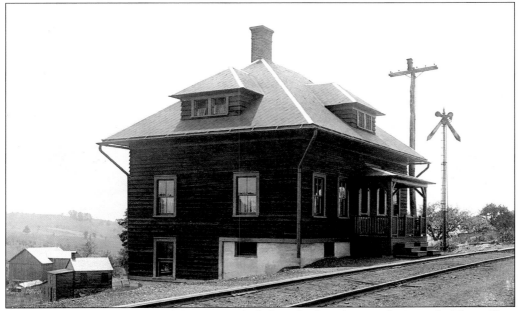

Summit was a remote railroad location uphill from both Sidney and Norwich. This office, photographed on June 30, 1911, replaced an earlier facility across the track and had living accommodations for its telegraph operators. Charles and Mary Wilson worked the first and second trick jobs here for years. (Courtesy Ontario & Western Railway Historical Society.)

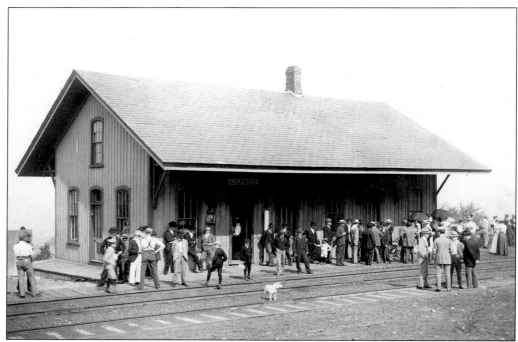

Because the NY & OM had to negotiate the divide between the Chenango and Unadilla valleys, its station serving Oxford (above) was high on the hill about three miles distant from the community. The Lackawanna's Oxford station (below) was more suitably located within the village limits. The Midland-built Oxford depot was the only station with curved window tops. When it burned down on October 5, 1931, it was not replaced. (Courtesy Sam Reeder and Chenango County Historical Society.)

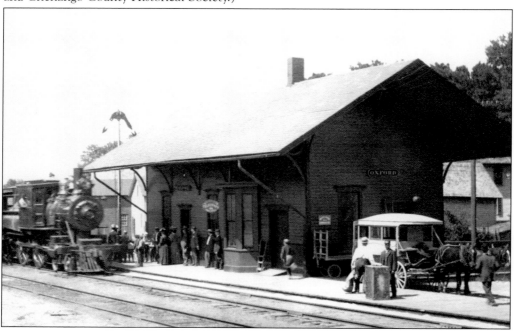

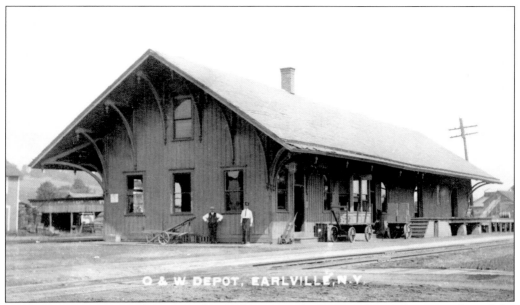

The community of Earlville was sandwiched between the NYO & W on the west side and the DL & W on the east. Both railroads provided station services from board-and-batten depots, the O & W's (above) being far superior in size to the Lackawanna's (below). The O & W station, presided over by agent Ed Sprague (left) and telegraph operator Claude Conger (right), was one of four Northern Division union stations since it also served the West Shore Branch of the New York Central. (Courtesy Sam Reeder and Quincy Square Museum.)

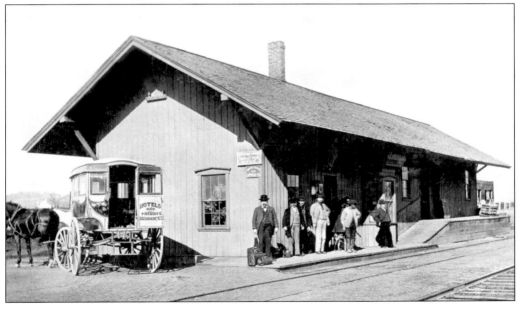

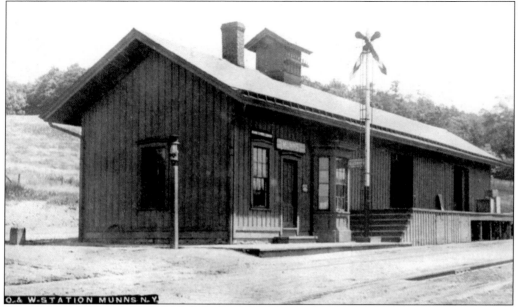

The O & W built only three board-and-batten stations that replaced earlier ones lost to fire. The Munnsville station, shown here in 1908, was built in late 1881 at a cost of $1,009.37. This is the building where the author lives and where this book was written. The other two board-and-batten depots built by the O & W were located at Randallsville and Mount Upton. (Photograph by Floyd Davenport, author's collection.)

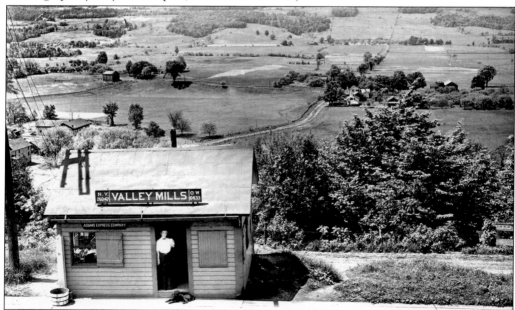

Some depots were not replaced with traditional depots after they met their demise. Such was the case at Valley Mills, where the 20- by 40-foot depot burned to the ground in 1893 and was replaced by this simple structure shortly thereafter. Laura Snell is standing in the doorway; the name of the lounging four-footer is unknown. (Photograph by Charles Stringer, courtesy Bruce Tracy.)

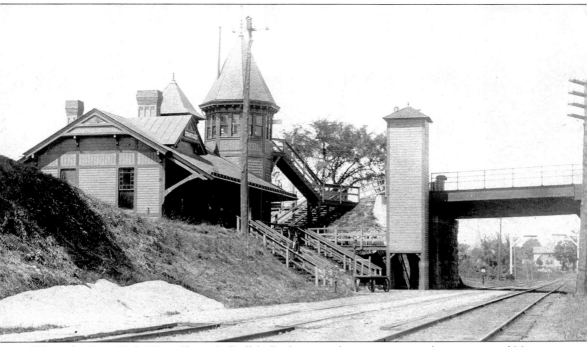

When the New York, West Shore & Buffalo Railway was being constructed across central New York, it crossed the O & W's Northern Division at Oneida Castle. At that location, the two railroads jointly built this fascinating Victorian station in 1884. Unique to both railroads, the building featured a turreted telegraph operator's room and a restaurant in addition to the ticket office and waiting rooms. The West Shore crossed over the O & W via bridge No. 352; the freestanding structure was an elevator used to transfer baggage between the two lines. In 1897, the O & W shortened the name of this station simply to "Castle." (Courtesy Bruce Tracy.)

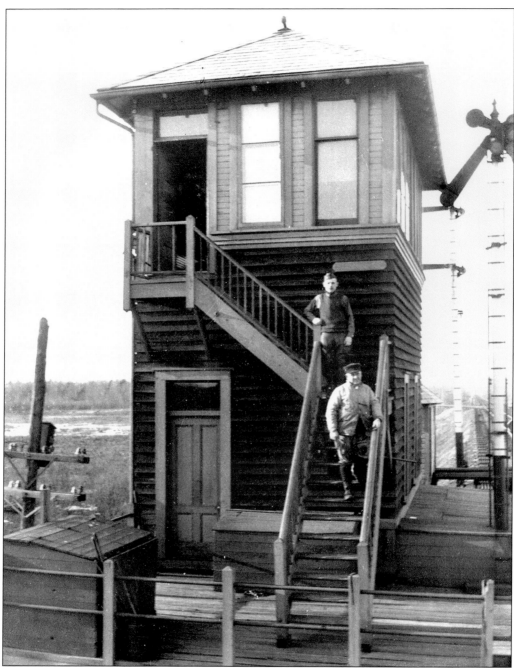

SX tower was the only interlocking tower operated solely by the O & W on its Northern Division. It sat astride the main track at Sylvan Junction and helped to streamline the operation of trains on the O & W main line and Sylvan Beach Loop, as well as Lehigh Valley Railroad trains that had rights over the O & W at this point. Pictured in 1919 are Leo Mengel (top), an SX towerman before World War I military service, and signal maintainer Doc Curtis. (Author's collection.)

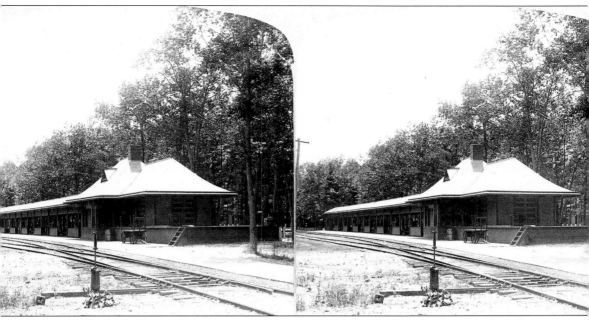

Before 1907, the Ontario & Western operated trains to Sylvan Beach on a seasonal scheduling that generally ran from the end of June to the beginning of September. The remainder of the year, their station sat unused, enjoying the solitude of its Oneida Lake setting. Such is the scene here of the 1893-built Sylvan Beach station. Tourists and summertime trains are not far off, as leaves have blossomed on the trees in the picnic grounds. After 1907, employing the services of SX tower, the O & W began running trains to the beach on a year-round basis. (Courtesy Bruce Tracy.)

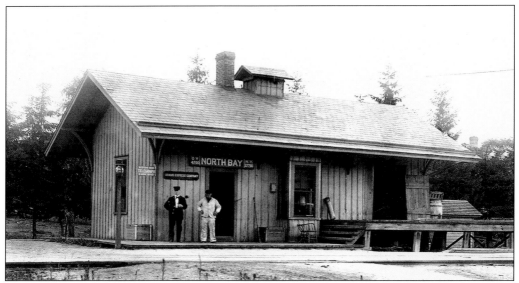

This depot at North Bay was built in 1878 by the Oswego Midland to replace an earlier structure. It sat overlooking the Edgewater Beach section of Oneida Lake. The O & W added the cupola and bay window, features of the other three O & W–built board-and-batten stations that the Midland depots lacked. (Courtesy Bruce Tracy.)

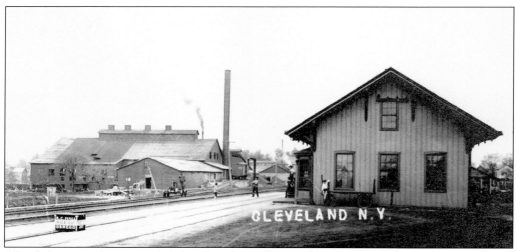

All of the ingredients needed for the glassmaking industry to flourish (such as sand and hardwood trees) could be found in and around Cleveland, New York. The last glass factory was Getman's Glass Company, which was situated across from the O & W depot. A bay window has been added to the Midland-built depot for the telegraph operator's convenience. (Courtesy Bruce Tracy.)

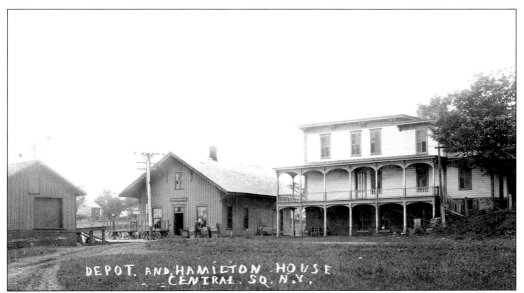

DEPOT. AND HAMILTON HOUSE
CENTRAL. SQ. N.Y.

When the Midland's rails reached Central Square, a standard 30- by 50-foot depot was built at the junction with the Rome, Watertown & Ogdensburg Railroad. The union station was situated right next to the Hamilton House (above) and when that hotel burned down on October 23, 1908, the fire also consumed the depot. Afterwards, a small shanty and combination coach were used as a temporary station (below); the charred remains of the hotel are to the right. (Both photographs courtesy Bruce Tracy.)

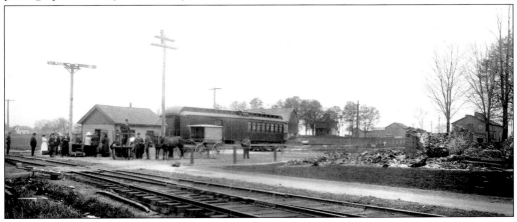

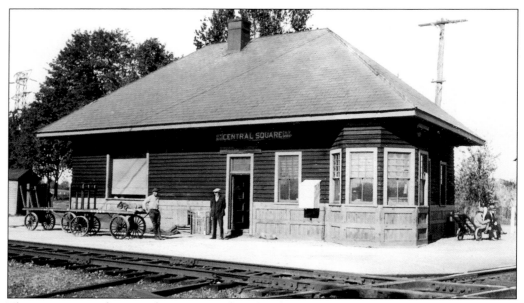

This attractive and unique depot, pictured on October 15, 1931, was erected as the new Central Square depot. Its main feature was a five-sided bay window that allowed the telegraph operator to view the crossing of the O & W and New York Central (previously RW & O) track in the right foreground. (Author's collection.)

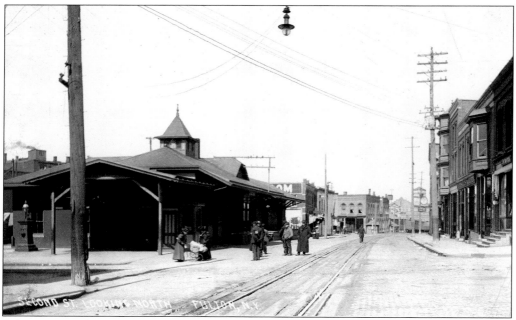

Fulton's Second Street station was another one-of-a-kind depot that served passenger trains of the O & W as well as those of the New York Central. Its rather urban setting belies the overwhelming rural quality of the O & W's right-of-way in this area. (Courtesy Bruce Tracy.)

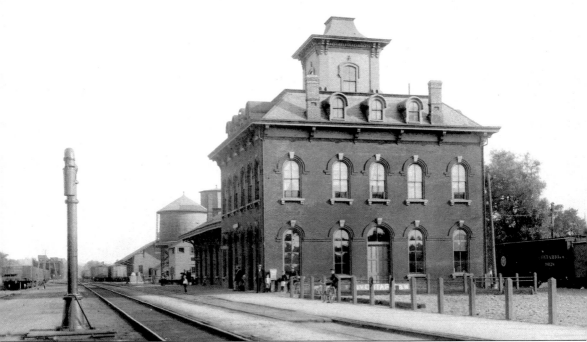

Of the three brick stations built by the New York & Oswego Midland Railroad, the structure that served Oneida was the most architecturally pleasing. The two-and-a-half-story station, topped by a mansard-roofed tower, housed all of the railroad's offices needed to support this important location and interchange with the New York Central Railroad's main line. The end of passenger service in 1929 spelled eventual doom for this grand station. Ten years later, it was sold for $200 and demolished. This view looks south, with a water tank and freight house beyond the station. (Courtesy Bruce Tracy.)

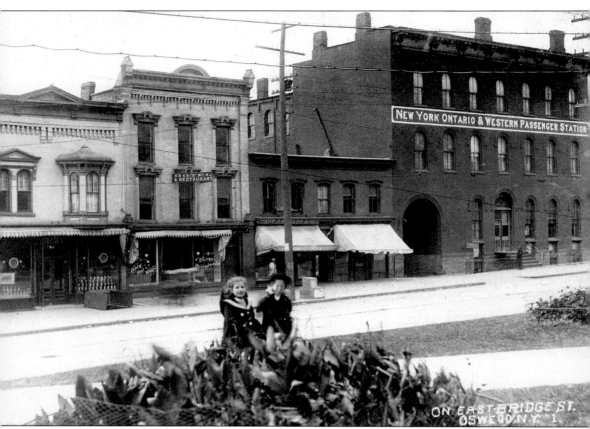

NEW YORK ONTARIO & WESTERN PASSENGER STATION

ON EAST BRIDGE ST.
OSWEGO N.Y. 1.

The Oswego station was situated at the corner of East Bridge and Third Streets and was the northern terminus of the Ontario & Western system. At this point, O & W passengers could transfer to New York Central trains to continue their journey west. For a brief period of time during the Midland years, the three-story brick structure served as the headquarters for the entire railroad, perhaps because Oswego was the home of Midland president Dewitt C. Littlejohn. (Courtesy Sue and John Hudson.)

Four

NORWICH

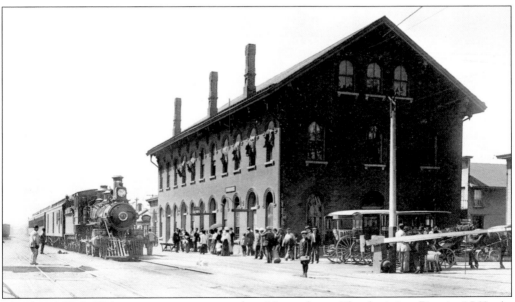

The first NY & OM passenger train arrived in Norwich on Thanksgiving Day in 1869. At that time, the Eagle Hotel served as the first ticket office, but the following year a three-story, unattractive but functional station was erected on East Main Street at the railroad's crossing. The station that housed the divisional offices until 1939 looks on as the Utica Flyer makes its Norwich stop. (Courtesy Sam Reeder.)

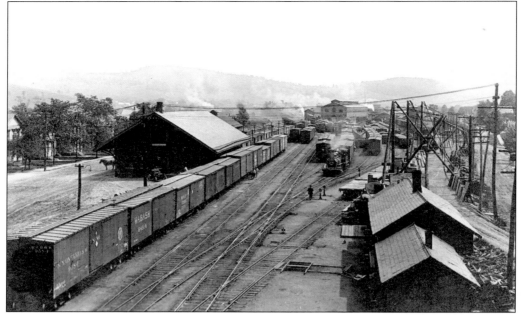

Shown in a view looking south from a third-floor station window, the sprawling Norwich yard completely overwhelms the scene. The freight house is to the left, and in the center distance the locomotive backshop towers over everything except the Chenango Valley hills beyond. (Courtesy Bruce Tracy.)

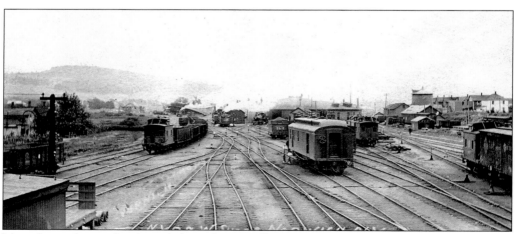

Myriad switches and sidings led to the roundhouse, water tank, backshop, car shop, and switching yard, collectively making the Norwich yard the most important facility on the Northern Division. The city aided Midland's construction to the tune of $523,600. (Courtesy Bruce Tracy.)

Seen from the backshop roof (above), the original circular roundhouse was equipped with a covered turntable. This facilitated the repair, turning, and placement of locomotives during the long snowy winter months. Working in the roundhouse was rough and dirty work. Roundhouse men sometimes had the arduous task of manually pushing an engine under repair onto the covered turntable (below), while derby-hatted master mechanic William A. Daley (right) looks on. (Both photographs courtesy Jack W. Farrell.)

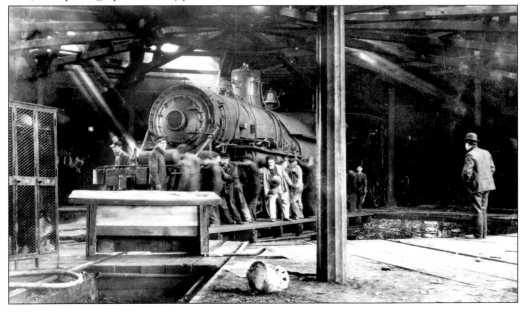

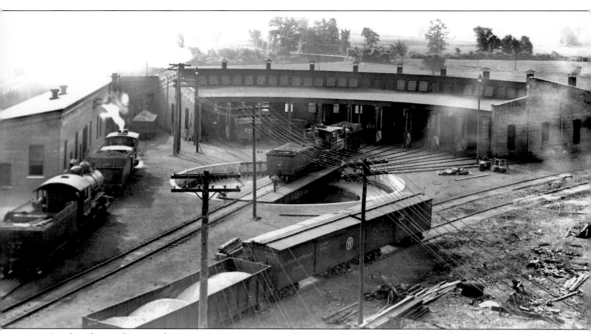

In the days of steam locomotive operation, the roundhouse could always be found by looking for the smoke emitted from the engines. The O & W's new 10-stall facility built in 1906 could be so located. This smaller, but more efficient, roundhouse replaced the original one pictured on the previous page, and it served the railroad until it was abandoned in 1957. (Courtesy Jack W. Farrell.)

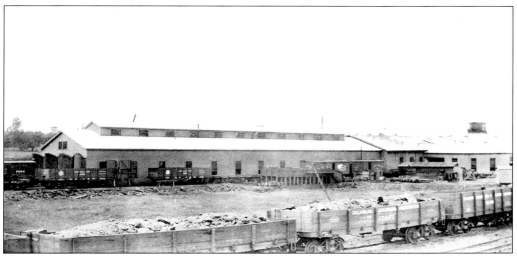

The lengthy three-track, wood-frame car shop was attached directly to the original circular roundhouse until it was consumed by fire on March 29, 1903. Between 1903 and 1915, the O & W completely rebuilt and modernized its Norwich yard facilities, which included a new car shop in 1904. (Courtesy Sam Reeder.)

The towering backshop (right) with its attached car shop and boiler houses, along with the stores department building (left), were only three years old when this picture was taken on July 21, 1910. Sneaking into the scene is engine No. 24. (Courtesy Jack Farrell.)

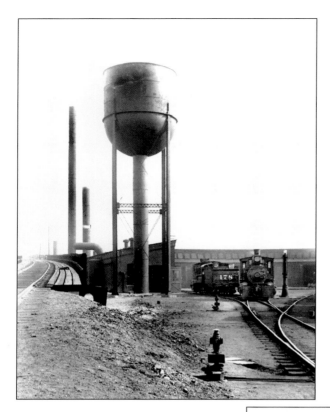

The new coaling trestle, water tank, and roundhouse are shown on April 19, 1915, with two engines standing at the water column fed by the tank. The cleanliness of the area should be attributed to these facilities being relatively new. (Courtesy Jack W. Farrell.)

Sand used for locomotive adhesion had to be absolutely dry or it would clog up the piping from the sand dome to the sanders. This sand-drying facility was conveniently placed next to the locomotive roundhouse. (Courtesy Jack W. Farrell.)

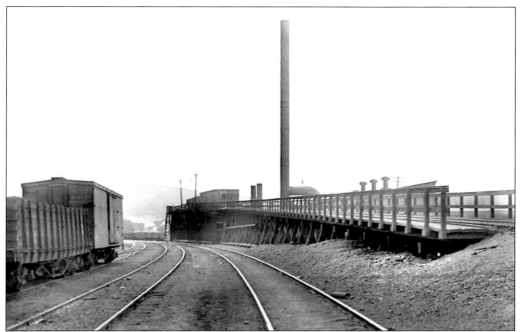

Before any steam locomotive could be sent out on the road with a train, the tender had to be filled with coal. Between 1903 and 1943, a coaling trestle (above) was used for this purpose. After 1943, and until the arrival of the diesels, steam locomotive tenders were fueled from the new coaling tower (below). Diesel locomotives such as FT No. 804 A & B scoffed at this antiquated appurtenance and purred right on by. (Courtesy Jack W. Farrell and Walter Kierzkowski.)

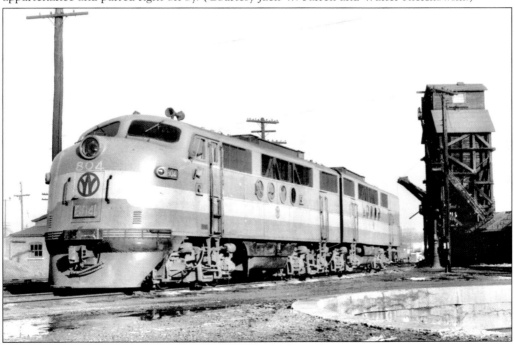

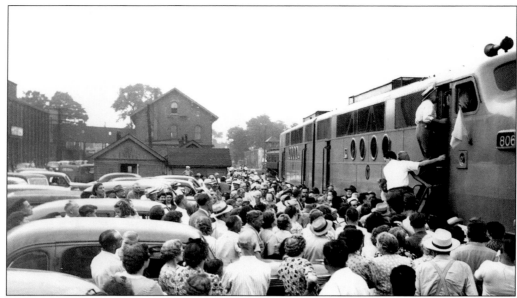

The O & W's first diesels to visit Norwich, the No. 806 A & B, arrived on July 25, 1945. Norwich citizens were allowed to inspect the engines and were quite enamored of the streamlined locomotives that were painted gray with yellow and orange accent colors. Shopmen used to the labor-intensive maintenance of steam locomotion, however, realized their ranks would be thinned by the internal-combustion intruders. (Courtesy Sam Reeder.)

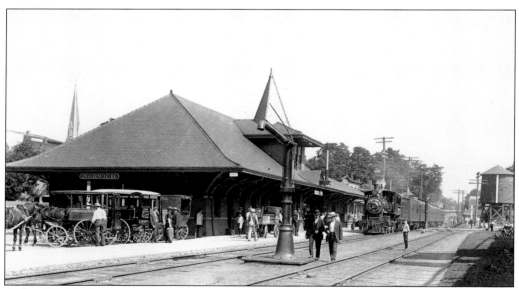

Only a few blocks west of the O & W station, but still on East Main Street, the Lackawanna's station also served the community of Norwich. A late-afternoon southbound passenger train brakes for its stop at the modern DL & W depot—competition indeed for the Ontario & Western service. The O & W employed many more residents of Norwich than did the DL & W, giving the O & W favorite road status. (Author's collection.)

The railroad YMCA on East Main Street catered to O & W train crews while they were awaiting their next call to service, and obviously these men did not mind putting on their Sunday best while they were idling away the off-duty hours. The first railroad YMCA was upstairs in the O & W depot; this building replaced those rooms in 1901. (Courtesy Chenango County Historical Society.)

The Borden Company operated a network of milk stations, creameries, and condenseries that were not only functional but attractive as well. In this eastward-looking view, the condensery at Wood's Corners, just north of Norwich, was served by the DL & W (foreground track) and by the O & W on the far side of the facility. (Courtesy Chenango County Historical Society.)

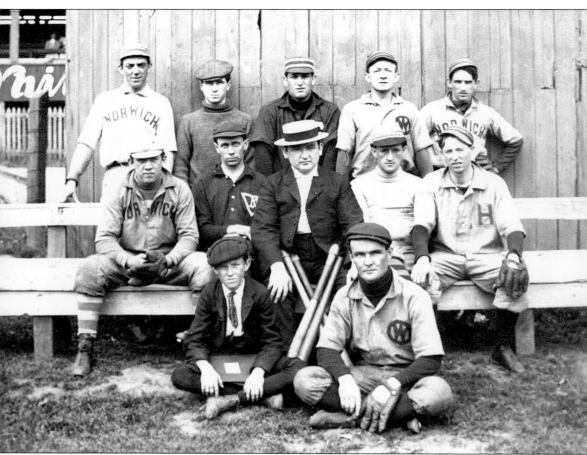

The Norwich all-star baseball team was composed of these players. From left to right are the following: (front row) Sandy Ford and Ed Harvey; (middle row) Bill Lincoln, Jude Merritt, Barney Lennon, Curly Stafford, and Joe Murphy; (back row) ? Bennyhoff, Tom Downey, Al Hausher, Walt Baker, and George Coleman. Take note of the O & W logo on the uniforms of Harvey and Baker. The O & W baseball diamond was located on Hale Street near the railroad's shops. (Courtesy Chenango County Historical Society.)

Five

MEN AND MACHINES

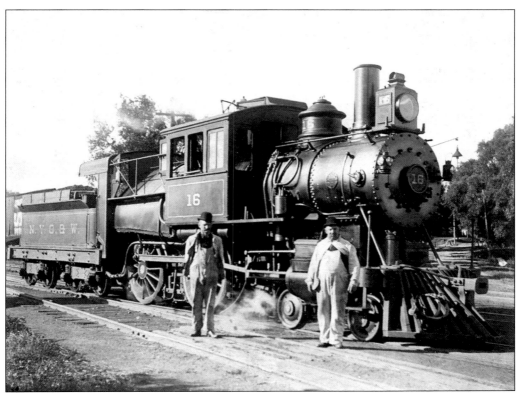

Fireman John Murphy (left) and engineer Bill Harding pose with their American-type camelback No. 16 at Walnut Street in Oneida. Their regular run was between Oneida and Sidney with milk trains No. 9 and No. 10. The link-and-pin coupler helps to date the scene as pre-1900. (Courtesy Jack W. Farrell.)

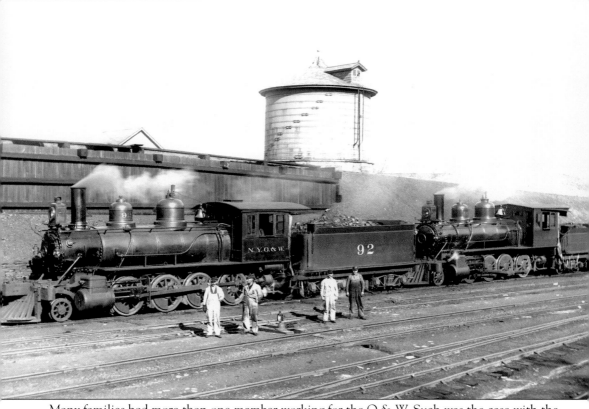

Many families had more than one member working for the O & W. Such was the case with the Weeden family of Norwich. Brothers Horatio (sometimes called Horace or "Race") and Archer were engineers for the railroad and, at one point in their careers, ran the Southern Division and Northern Division (respectively) pushers out of Sidney. In that capacity, the brothers are shown with their N-class Consolidations at the coaling trestle at that division point. Horace (left) ran the No. 92, while Archer (third from left) piloted the No. 91 with Bill McDonald (right) as fireman. The No. 91 is shown at work on page 36. (Courtesy Ontario & Western Railway Historical Society.)

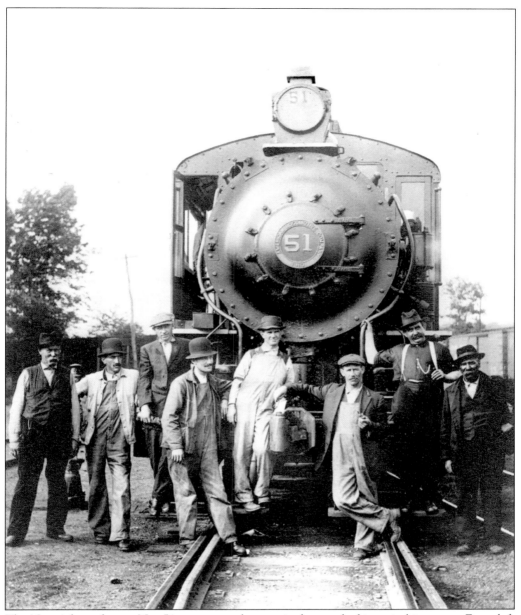

The Norwich yard goat, No. 51, appears to be genuinely proud of its switching crew. From left to right are Walt Stevens, Mike Larkins, Emerson "Pop" Morse, Jim Gibbons, Dad Warren, Nels Dun, Hank VanGardner, and Franz Romer. Railroading in the early 20th century was a labor-intensive affair, especially in flat-switching yards like Norwich. Uncoupling cars, braking, switch throwing, and signal passing all had to be done by seasoned railroad men. (Courtesy Chenango County Historical Society.)

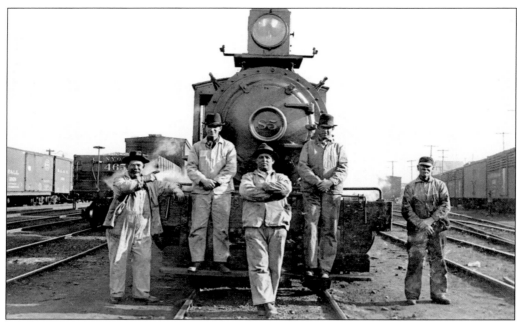

On another occasion, No. 85 (a 2-8-0, above) was the Norwich yard-switching engine whose crew members are all unidentified except for the gent to the left. He is George Lincoln, the engineer. Losing an eye cost Lincoln his job in train service, but the O & W allowed him to remain at the throttle within yard limits. Sectionmen (below) had their own type of machine to get around on. The old pump car gave way to the gasoline speeder, making life easier and less tiresome for Fred Fairchild (front) and his crew, who worked Section No. 9 at Galena. (Courtesy Bruce Tracy and North Norwich historian Jan Decker.)

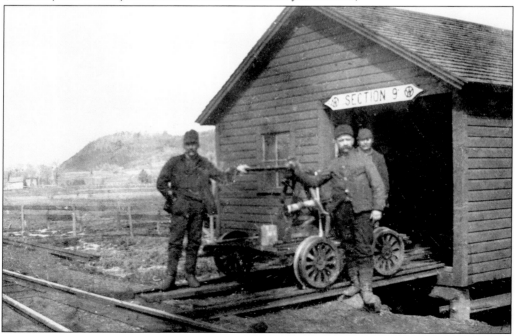

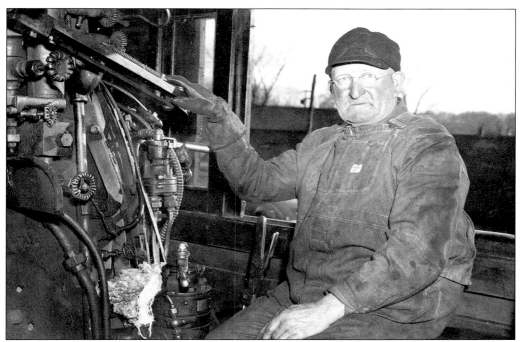

Engineer Lew Eaton (above) ended his long O & W career switching in the Oneida yard. Reverse lever, brake valves, sander lever, site glass, injector valves, and throttle bar were the working environment for the man in the right-hand seat of a steam locomotive. An experienced man such as Eaton used these "tools" to perfection. While Eaton's right hand rests on the throttle, Matt Dixon's hand (below) rests on one of the 40 levers housed in SX tower. These levers, with connecting pipes, allowed setting signals and switches for trains to pass through the tower's plant safely. (Both photographs courtesy Jack W. Farrell.)

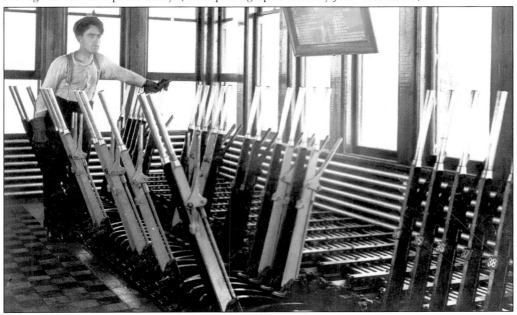

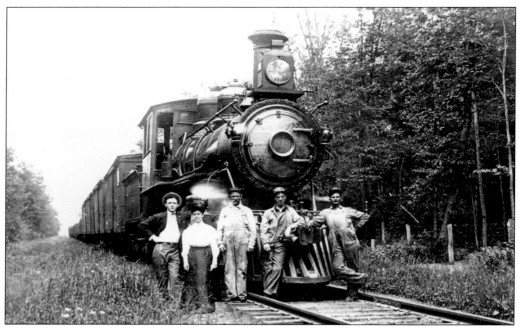

A southbound freight train stopped on the Sylvan Beach Loop provides the backdrop for this impromptu photograph. From left to right are O & W agent Art Peck, his wife, engineer Augustus Rowe, fireman Ed Demarsh, and brakeman Bill Lennor. Before SX tower was built, the Sylvan Beach Loop was used only during the summer season. (Author's collection.)

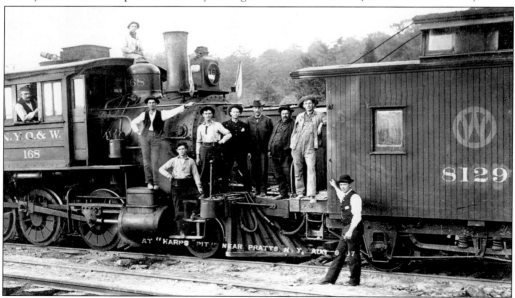

During the summer of 1909, several work trains and crews labored in the Stockbridge Valley filling wooden trestles with dirt. Dickson Hog No. 168 and four-wheel bobber caboose No. 8129 were so employed, along with engineer Charles Coleman (in cab window), Irv Haitz (on cylinder valve cover), Wilbur Cassel (pilot step), foreman Nate Towne (thin man standing on coupler), and conductor Del Allen (on the ground). (Courtesy Sam Reeder.)

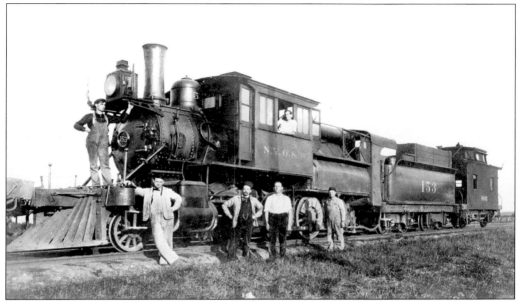

In 1906, the O & W was raising its track approaching the new bridge over the Barge Canal at Fish Creek. Consolidation No. 153 takes a break during this process. Standing on the ground are, from left to right, engineer Jesse Harding, conductor Mott Breed, brakeman Art Simpson, and fireman John Spauling. Bethinger and Wells are on the pilot and in the cab, respectively. (Courtesy Jack W. Farrell.)

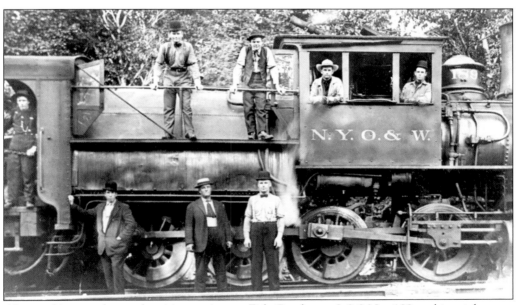

Also working on the track-raising project at Fish Creek was 2-8-0 No. 189 and its eight-man crew. Their picture was taken near the North Bay depot, and it seems as though the Dickson Hogs prevailed in work train service. (Author's collection.)

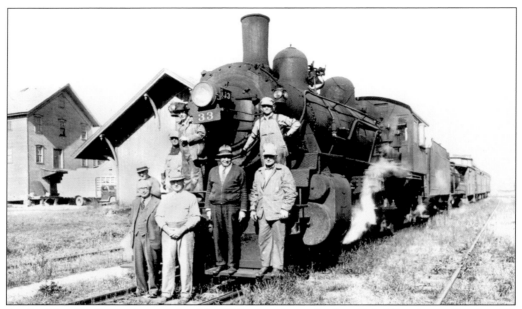

At the New Berlin station, engine No. 33 has made up the last O & W train on October 20, 1941. The next day, the branch would be run by the Unadilla Valley Railway. Honoring the event are, from left to right, the following: (on the ground) retired agent Frank Bradley and E. Gray; (on the footboards) Ira Avery, agent Lester VanBuren, and conductor Stratton; (on the pilot deck) engineer Howe, flagman Natoli, and brakeman McGarity. (Courtesy Chenango County Historical Society.)

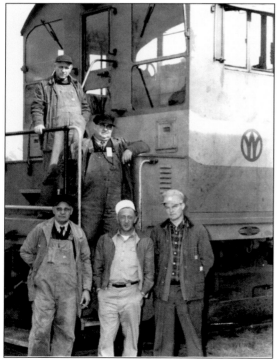

On the day of the O & W's abandonment, these men took Extra No. 116 South from Oneida to Norwich. Standing in front are, from left to right, trainman David Miller, fireman John Hahn, and trainman Charles Anderson. Frank Sherman (top) was the engineer, and George Hitchcock (center) was the conductor. (Author's collection.)

Six

WRECKS

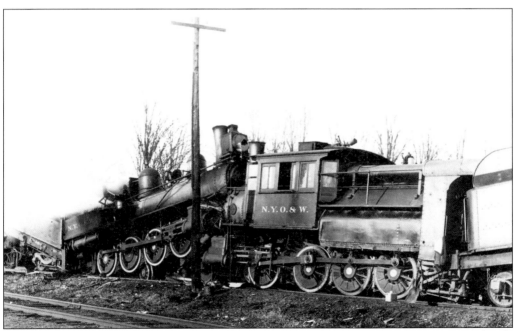

At Fulton on Halloween 1910, a wreck occurred on the O & W that was a Rowe family embarrassment. Father Augustus was the engineer of No. 80 (left), and his son Fred, the engineer of No. 153 (right). Fred's train was stopped when the father's engine created the cornfield meet. Adding insult to injury, son Bill was Augustus's fireman! None of the Rowes were injured. (Courtesy Sam Reeder.)

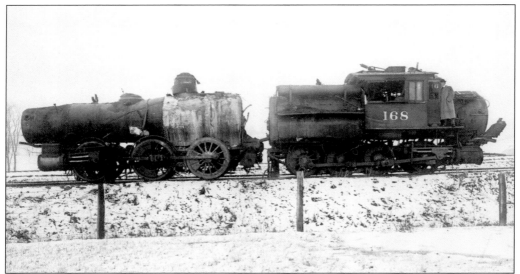

In the early-evening darkness of March 12, 1912, a head-on collision occurred between two O & W trains at Sturges Crossing just north of Galena. Train No. 29 was proceeding north with engineer Fred Kingman at the throttle and fireman Dave Ivory handling the scoop. Train orders in Kingman's pocket instructed him to meet southbound Extra No. 104 at Wilbers, but for an unknown reason, Extra No. 104 (John Adams, engineer, and Irving Cole, fireman) disregarded their order to meet train No. 29 at Wilbers. The ensuing cornfield meet caused the death of Kingman and Cole, reduced both locomotives to inoperable hulks (above), and piled up the following freight cars on the right-of-way (below). (Both photographs courtesy Chenango County Historical Society.)

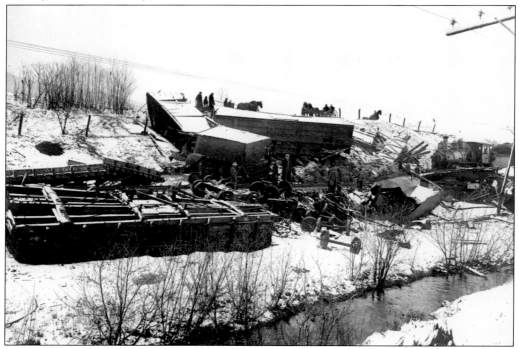

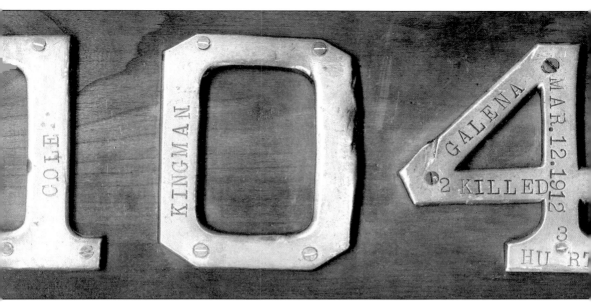

The Sturges Crossing wreck was memorialized by using Extra No. 104's engine number with appropriate stampings. (Courtesy Chenango County Historical Society.)

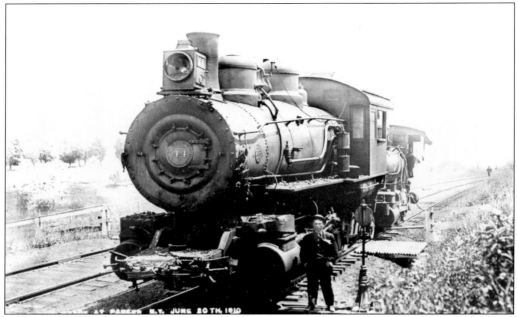

Three deaths and 17 injuries resulted from a wreck at Parker on June 20, 1910. Pusher engineer B. A. Kingman, Fred's brother, was running southward in reverse after assisting a train to Summit when his engine collided with the second section of northward train No. 5 at 2:30 in the morning. Both engines, shown here, were disabled. (Author's collection.)

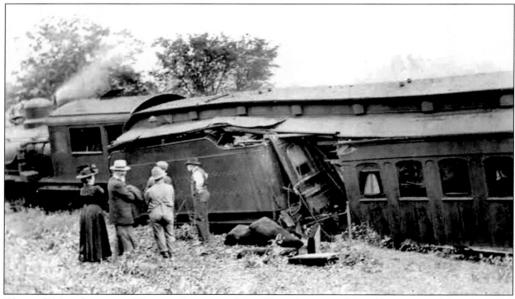

The collision between Kingman's engine No. 92 and engine No. 44 on train No. 5 caused No. 44's tender to telescope in to coach No. 21, totally destroying the end of the passenger coach. All enginemen survived the crash, but those riding in the coach were not so lucky. (Courtesy Town of Guilford historian Tom Gray.)

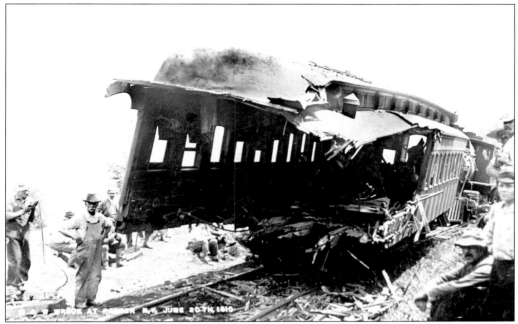

Three passengers were killed inside telescoped coach No. 21, and 17 others were injured. Section foreman Austin Bourn (hands on hips at left) poses next to the destroyed car after daylight on June 20, 1910. (Courtesy Bruce Tracy.)

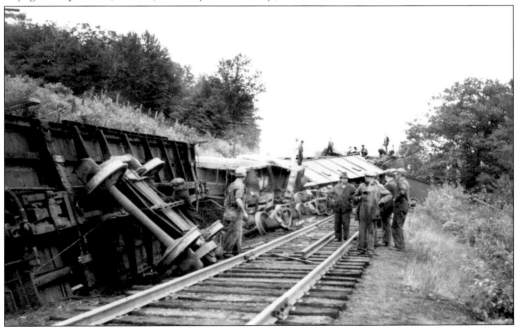

Parker was the site of another wreck on August 18, 1938. A broken rail caused the derailment of southbound train US-2, overturning a number of freight cars and effectively blocking the single-track line from service. Wreckmaster Al Boyd from Mayfield Yard suffered a heart attack and died while supervising the cleanup of this wreck. (Author's collection.)

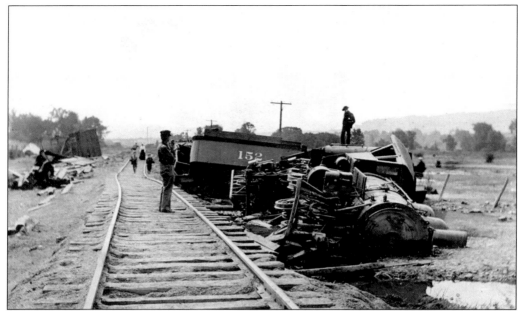

On September 4, 1905, engineer Henry "Windy" Norton lost his life in this wreck at Woods Corners. His engine, No. 152, along with helper engine No. 33, derailed because of a softened roadbed caused by an earlier flood in the area. Norton's fireman, Emil Mesbauer, and the crew of No. 33 all survived. (Courtesy Chenango County Historical Society.)

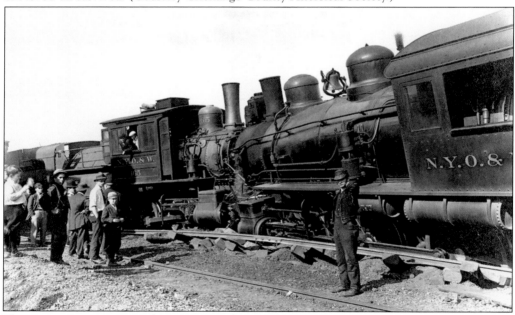

The circumstances surrounding some Northern Division wrecks has been lost with the passage of time, but when engines met head-on, as shown here, human error was most likely the cause. Many curious onlookers descended on the site of a cornfield meet as soon as the dust settled. These young fellows will have a good story to tell their teacher at school tomorrow. (Courtesy Chenango County Historical Society.)

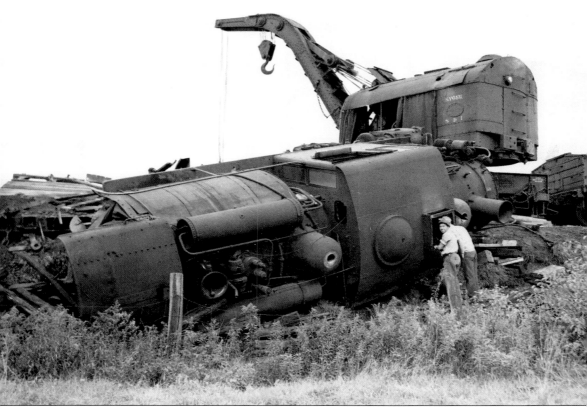

Engineer Bob Haggerty and fireman Clay Platner were both killed when they allowed their engine, No. 50, to foul the main track at the south end of Norwich yard. It was struck by a passing northbound diesel-powered freight train, which rammed the tender, causing the No. 50 to overturn. Both men on the old-fashioned Mother Hubbard were pinned under the locomotive when it came to rest. At the ensuing investigation, eyewitnesses testified that Haggerty and Platner never knew what hit them. Steam crane SD-1 clears the site not long after the September 17, 1945 wreck. (Courtesy Chenango County Historical Society.)

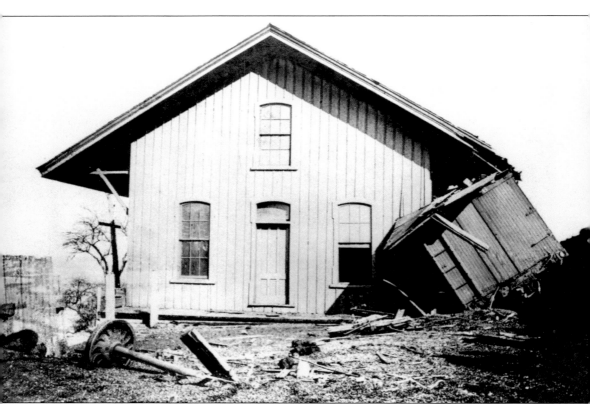

The Oxford depot and 25 freight cars were the only casualties of a wreck that occurred on March 6, 1903. It seems that a slow-moving northbound merchandise train No. 30 had not completely entered the Barber's Switch siding when a downgrade coal train, with Fred Kingman at the throttle, sideswiped the upgrade train. The collision caused the splintering of some freight cars to kindling wood, while at least one boxcar was thrown into the depot, knocking it off its foundation. Agent Frank Cating, in the station at the time, was unhurt. The story, however, had a happy ending. The O & W sent a B & B (bridge and building) gang to right the depot, and after so doing they added a bay window, making it easier for Frank to watch the approach of all future trains. (Courtesy Sam Reeder.)

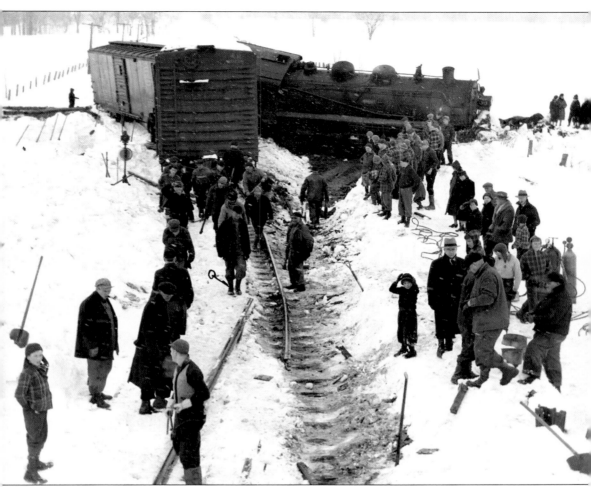

Not long after northbound train WA-1 left Oneida on March 17, 1940, the wreckmaster's train had to be called out to clean up this mess at Durhamville. Consolidation No. 313 headed the train with engineer Howard Baker, fireman Joseph Whitney, and head brakeman Harold Breed all riding in the cab. As their train approached the Durhamville depot, the locomotive derailed on ice built up in the flangeways of a crossing, slid sideways, but remained upright when it came to rest. Not long after the derailment, an enterprising photographer captured the locomotive while sidewalk superintendents tried to determine what happened. (Author's collection.)

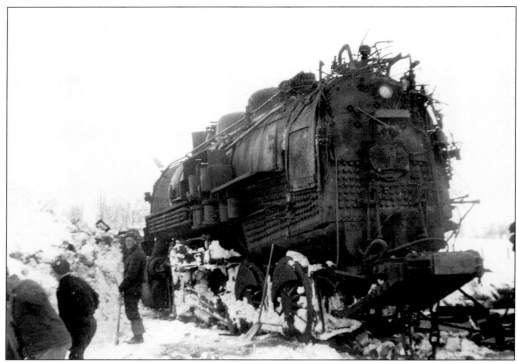

The W-class 2-8-0 No. 313 has been stripped of its cab (above) to facilitate rerailing by the wreck crane (below). Once the locomotive is back on a section of temporary track, it will be "walked" to the main track for rerailing. While all this was going on, the line was out of service to all train movements, making the life of the wreckmaster quite uneasy until he cleared the line. (Both photographs author's collection.)

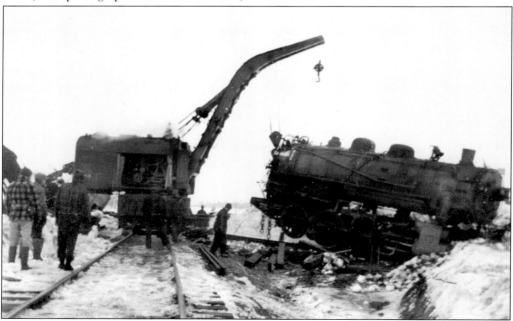

Seven

BRIDGE AND BUILDING DEPARTMENT

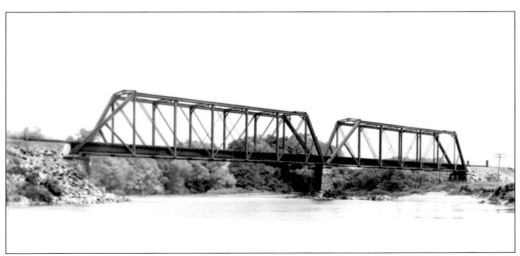

Bridge No. 238, a steel riveted double-span truss bridge 154.46 feet in length, provided all O & W trains a crossing of the Susquehanna River. It was located at the northern limits of Sidney and, like all steel bridges, replaced earlier iron and timber structures. The new bridge is pictured on July 9, 1913. (Courtesy Jack W. Farrell.)

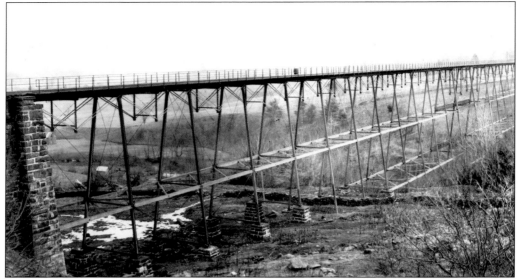

The Lyon Brook Bridge, officially designated bridge No. 282, was the first wonder of the Oswego Midland's world. The gorge of the Lyon Brook was thought to be unconquerable, but engineer Beales (left) proved all doubters wrong. He designed, built, and completed the original bridge over the Lyon Brook (above) so that on January 1, 1870, locomotive engineer Emory Card was able to draw the first excursion train across the span. This original bridge was a rather spindly affair on which speed and weight restrictions were always employed. In 1894, the O & W's assistant engineer Curtis Knickerbocker rebuilt the 820-foot-long and 170-foot-high single-track bridge without delaying a single train. (Courtesy Ontario & Western Railway Historical Society and Clyde Conrow.)

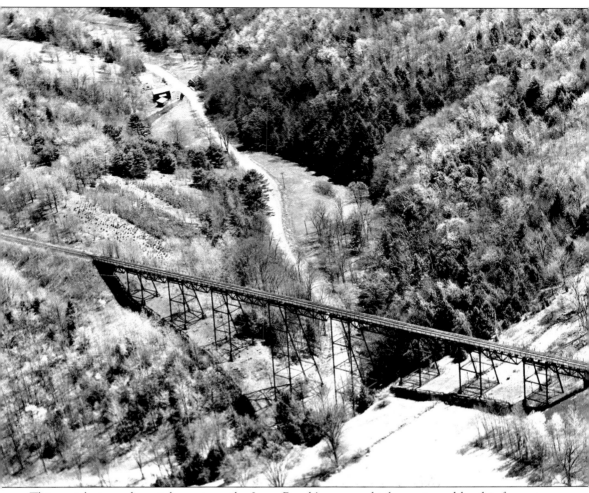

This aerial view adequately portrays the Lyon Brook's gorge, which was tamed by this famous bridge between Norwich and Oxford. (Courtesy Chenango County Historical Society.)

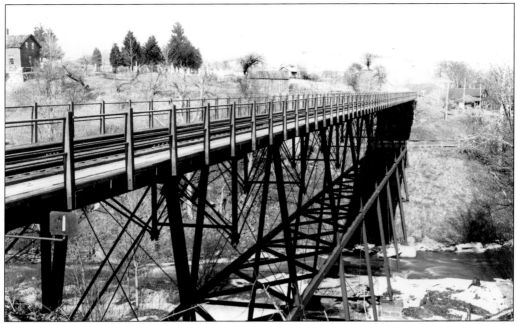

New Berlin Branch Bridge No. 1 was noteworthy to that branch, as the Lyon Brook Bridge was to the main line. Spanning the Guilford Creek at East Guilford, this bridge was 335 feet in length and 54 feet in height, making it the largest such structure on the branch. (Courtesy Ontario & Western Railway Historical Society.)

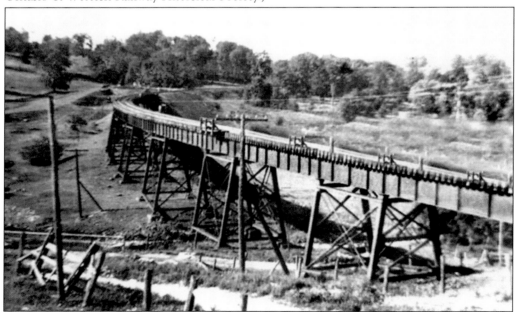

The Humphrey's Trestle, bridge No. 250, was located between East Guilford and Parkers. In this view looking north, the 690-foot-long and 42-foot-high structure spans the Guilford Creek and the Ives Settlement Road. The bridge was named for an early Guilford railroad commissioner. (Courtesy Town of Guilford historian Tom Gray.)

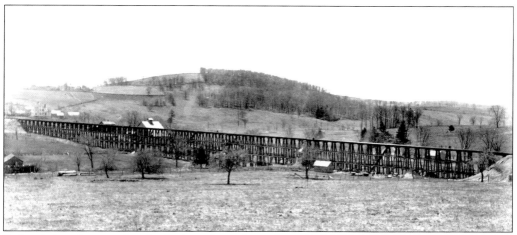

Before being shortened and rebuilt with steel members, O & W bridge No. 274 (above) stands in its timber form not quite 800 feet in length. As testimony to the fact that riding the O & W was a scenic delight, passengers riding across this bridge were treated to a view (below) of Rugg's Pond, later renamed Oxford Pond. The bridge was situated a short distance south of the Oxford depot. Today's county Route 35, built after the O & W's abandonment, slices through the location of this lengthy trestle. (Courtesy Ontario & Western Railway Historical Society and Jack W. Farrell.)

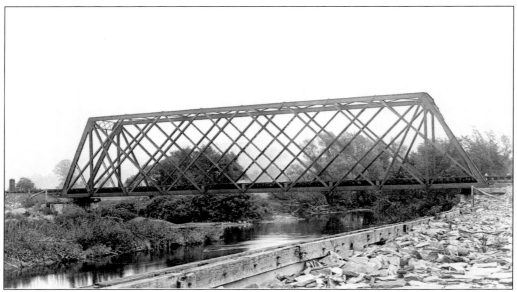

During the early life of the New York, Ontario & Western Railway, the majority of the bridges on its line were completely rebuilt. This was occasioned by the railroad's emergence as a coal carrier where heavy trains and increasingly heavier locomotives predominated. Bridge No. 298, which spanned the Chenango River north of Norwich yard, was one such bridge whose early span (above) was replaced by a more substantial structure (below) during the second decade of the 20th century. (Both photographs courtesy Ontario & Western Railway Historical Society.)

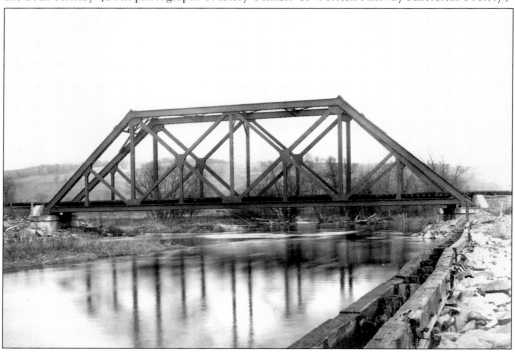

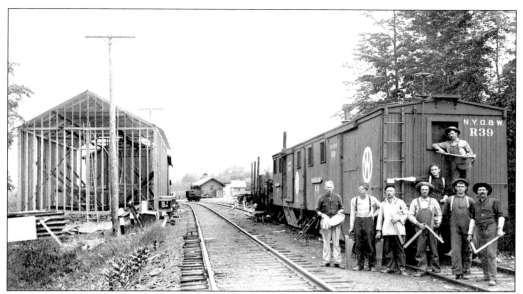

In order for the O & W to develop some degree of traffic base along its predominately rural line, it began to construct milk stations, creameries, and icehouses where farmers could deliver their milk for shipment to the New York City market—on the O & W, of course. This building process developed over time and eventually propelled the railroad in to being the leading supplier of milk to Gotham. On July 5, 1907, foreman Burlingnett's bridge and building gang (above) poses at Munnsville while erecting a new icehouse to the left. In the distance is the depot. The Morrisville milk facility (below) is another product of the railroad carpenter's effort. Agent Henry T. Lewis stands at the building's foundation. (Courtesy Sam Reeder and Jack W. Farrell.)

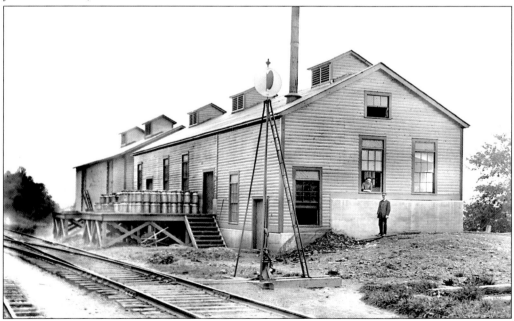

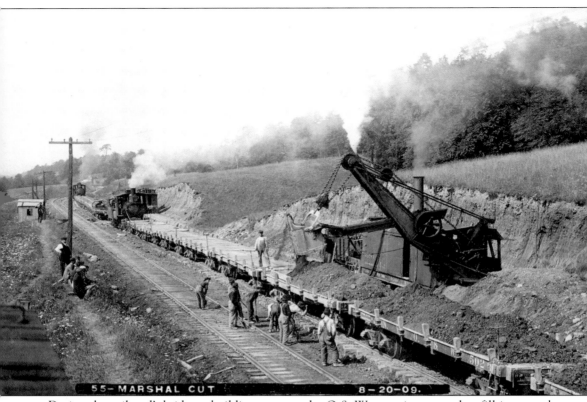

55-MARSHAL CUT 8-20-09.

During the railroad's bridge-rebuilding process, the O & W sometimes opted to fill in a trestle with dirt and provide a highway underpass if needed. Such was the decision for a bridge in the Stockbridge Valley. Beginning in 1907 and ending during the summer of 1909, bridge No. 332 was transformed from a wooden trestle to an earthen embankment with a concrete underpass provided for early vehicles. A "borrow pit" was established at Marshall's (above), where dirt was placed on flatcars to be deposited into the trestle framework. (Courtesy Sam Reeder.)

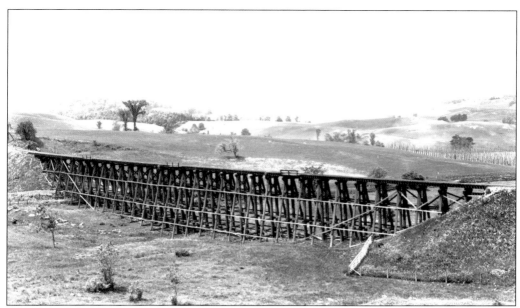

Bridge No. 332 (above) stands as built, but by the summer of 1909, its final form (below) has been realized. (Both photographs courtesy Ontario & Western Railway Historical Society.)

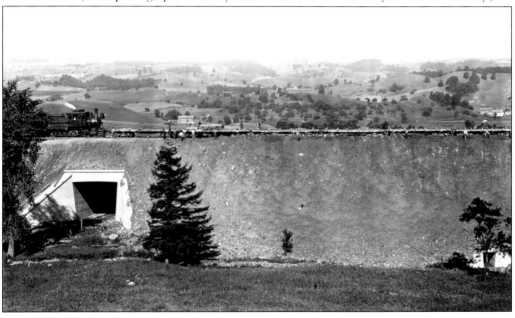

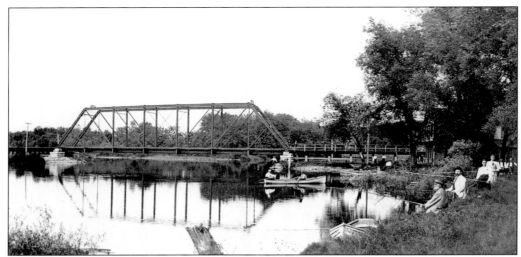

Another location where a transformation of an O & W bridge took place was at Sylvan Junction, near Fish Creek. There, an 1886-built bridge (above) was to be improved for the eventual building of New York's Barge Canal. In order to rebuild and raise bridge No. 367, a temporary trestle (below) was employed to keep the railroad operable. Then a completely new single-span bridge was erected that would be long and high enough to span the channel for the new canal. (Courtesy Bruce Tracy and New York State Museum.)

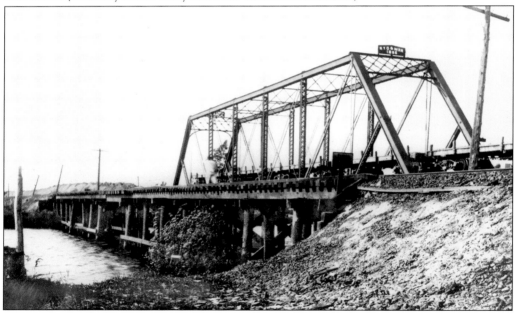

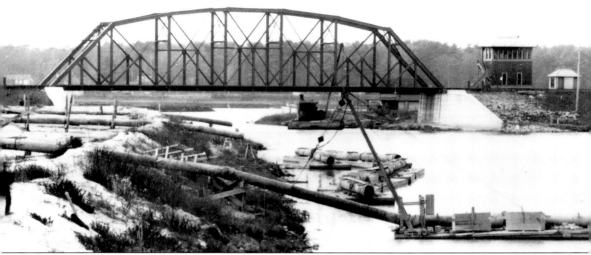

The completed bridge and SX tower are shown here on November 10, 1909. Because this work was done to accommodate the canal, the state paid the entire cost of reconfiguring the railroad's facilities here at Fish Creek. (Courtesy New York State Museum.)

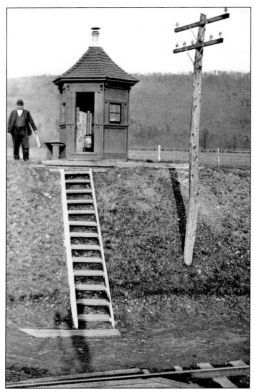

With ever increasing highway traffic, the state highway that crossed the O & W and DL & W tracks at grade in Galena eventually had to be bridged. Until the new highway bridge (facing page) was completed in 1911, Nick Bath guarded the grade-level crossing (left) for almost 30 years. Bath had lost an arm to a link-and-pin coupling in the Norwich yards. For all those years, he protected highway vehicles from speeding trains such as the southbound DL & W locomotive leading a passenger train (below). The O & W's track is in the foreground in both pictures. (Courtesy Peck family and North Norwich historian Jan Decker.)

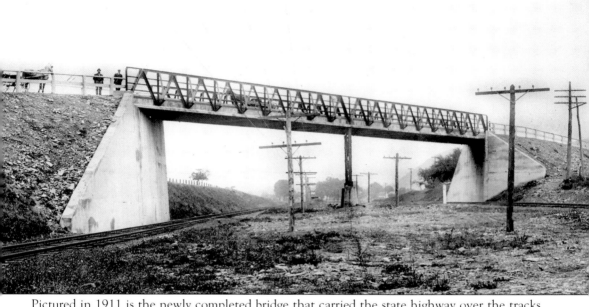

Pictured in 1911 is the newly completed bridge that carried the state highway over the tracks of the DL & W (left) and O & W (right) in Galena. (Author's collection.)

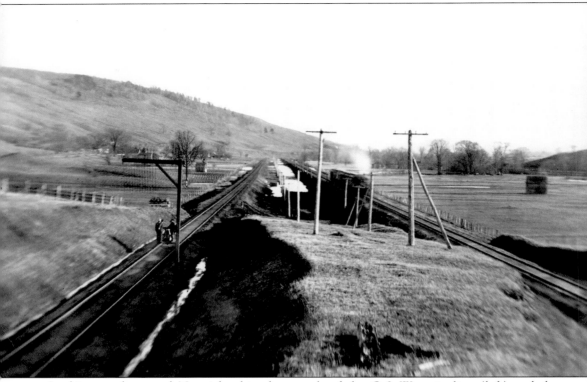

Looking south toward Norwich, this photograph of the O & W main line (left) and the Lackawanna main line (right) was taken from the old bridge at Plasterville. Because of the proximity of main-line tracks and similar passenger train scheduling, this section of the railroad's right-of-way was unofficially referred to as "the racetrack." Stories of Norwich-bound trains racing each other to get to their depot in the county seat first are common. In this scene, the O & W sectionmen on their hand-pump car are no match for the speeding northbound Lackawanna passenger train. Today, only the track to the right remains. (Courtesy Chenango County Historical Society.)

Looking north toward Sherburne Four Corners, this 1913 Asa Peck photograph shows the Lackawanna's overcrossing of the O & W main line via bridge No. 306. The DL & W track direction here was southward to Norwich (left), and northward to Utica (right). Standing on the bridge is the photographer's wife, Cecilia. (Courtesy Peck family.)

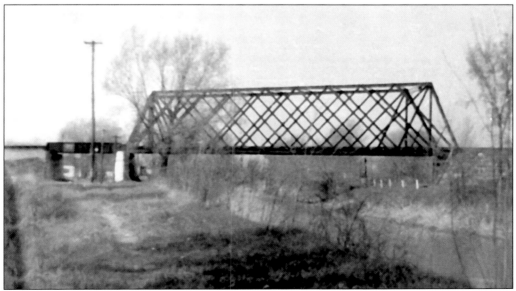

The Erie Canal and the O & W Northern Division main line crossed paths via bridge No. 361 just south of the State Bridge depot. Despite the fact that this bridge had been rebuilt in the late 1890s, it was never further improved, a circumstance that caused weight and speed restrictions on trains until the March 29, 1957 abandonment. (Author's collection.)

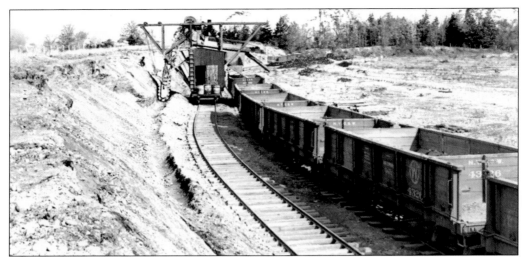

Near Earlville, a company gravel loader works to fill a cut of O & W gondolas with material for construction projects throughout the Northern Division. Purchasing land and operating gravel beds and borrow pits meant a financial strain the railroad had to bear to keep their facilities in tip-top shape. (Courtesy Jack W. Farrell.)

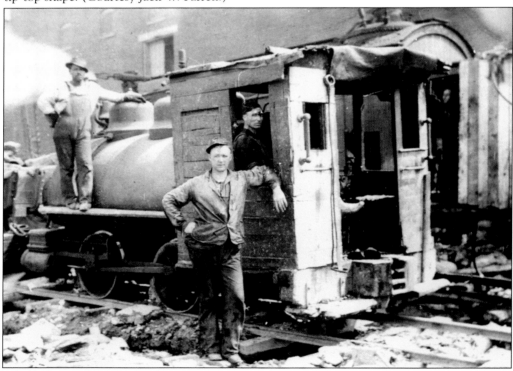

Of all the grade crossing elimination projects mandated by the New York Public Service Commission, none were more ambitious than the Fulton bypass, built in 1927–1928. Street running and 16 crossings were eliminated by the new line built east of the village. This 0-4-0 helped in that construction process. "Big Rowdy" Galvin (foreground) used his experience with the dinky engine to become a New York Central engineer. (Courtesy Sam Reeder.)

Eight

THE FOURTH "R"— RAILROADIN'

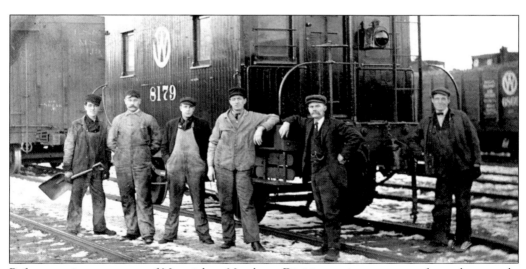

Before starting a run out of Norwich, a Northern Division train crew poses for a photograph. They are, from left to right, fireman Bill Welch, engineer Fred Kingman, trainmen John Breed and Abe Cole, conductor John Dorman, and trainman Ed Sharpe. Kingman was crushed to death by a boxcar as a result of a head-on collision at Galena on March 12, 1912. (Courtesy Bruce Tracy.)

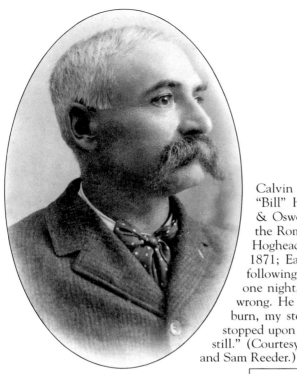

Calvin "Cal" Sanford (left) and William E. "Bill" Harding (below) were early New York & Oswego Midland engineers who came from the Rome, Watertown & Ogdensburg Railroad. Hoghead Bill's seniority dated back to May 1, 1871; Eagle-eye Cal came to the Midland the following year. With his train stalled on a hill one night, a riding inspector asked Cal what was wrong. He replied, "My coal is poor and will not burn, my steam is gone not to return. And so we stopped upon the hill, the angels whispered Peace be still." (Courtesy Chenango County Historical Society and Sam Reeder.)

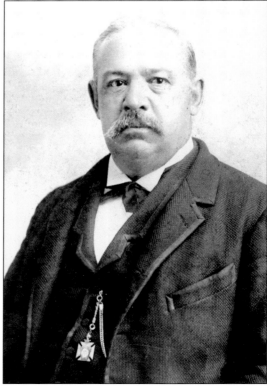

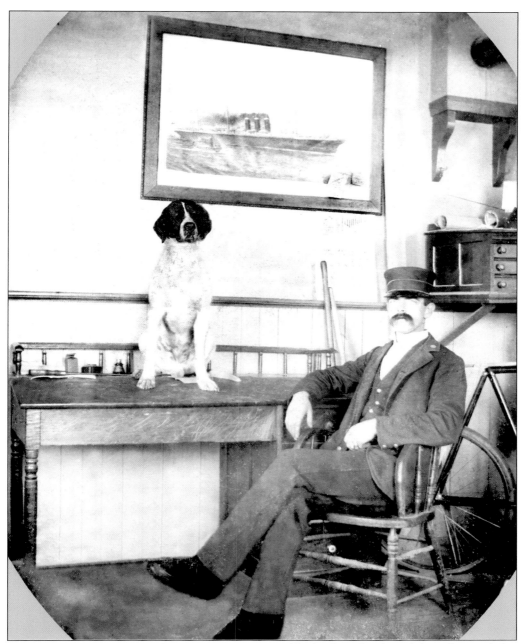

Morell Jerome Kinney was the station agent at Guilford, where he shared the office with his dog Flip, a pointer. Sometime during Kinney's decade of service for the Ontario & Western (March 1894–June 1904), this portrait was taken inside the original former schoolhouse depot. Agent Kinney's railroad career was cut short by his untimely death at age 30. (Courtesy Town of Guilford historian Tom Gray.)

Roadmaster Mike Finnegan (left) and Luther Nicholson (below) both made sure that the O & W track and roadbed were in tip-top shape for the Ontario & Western trains. Finnegan supervised all sectionmen between Norwich and Utica for 61 years, and Lute was the foreman who worked for him on the Galena section. In addition to serving the O & W, Finnegan was also a Norwich Alderman, and Lute furthered the interests of the International Order of Red Men, whose ribbons and cap he displays in this portrait. (Courtesy Chenango County Historical Society and North Norwich historian Jan Decker.)

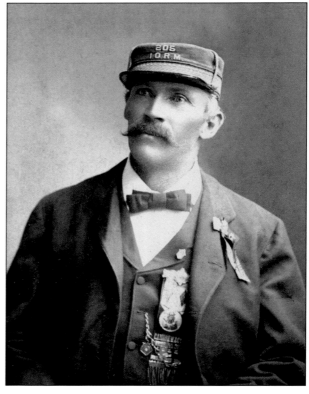

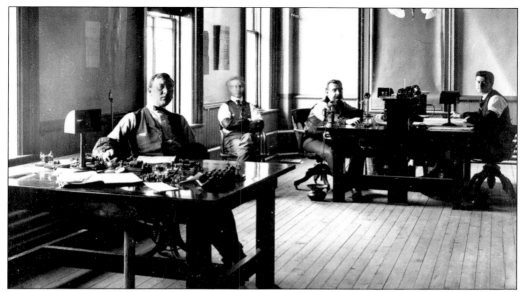

Sometime during the first decade of the 20th century, the staff of the Norwich train dispatchers' office poses for a photograph. From left to right are wire operator Crosby Smith, trainmaster John Smith, train dispatcher Charles W. Potter, and copy operator Albert Ferris. These men worked to keep the Northern Division's train operations running smoothly and safely. Operator Smith was known as the most proficient "lightning slinger" on the O & W. (Courtesy Clyde Conrow.)

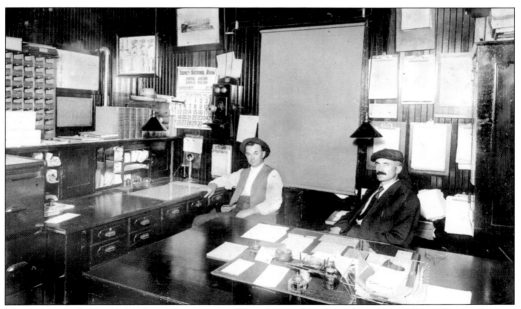

The joint O & W–D & H car foreman's office, located within the new Sidney freight house, is where car foreman Tenbrooke (left) and Clerk Wilber (right) worked to keep track of car interchange between the two busy railroads. Shaded incandescent lights, a wall phone, desk mounted telegraph instruments, myriad papers, and the essential calendar were all part of their working environment. (Courtesy Clyde Conrow.)

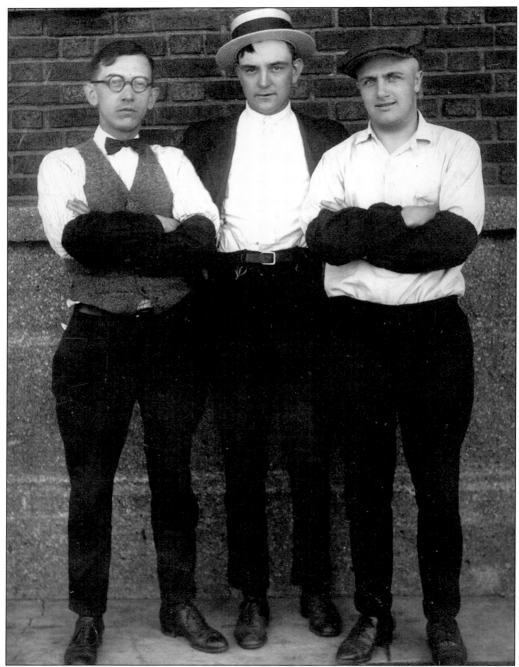

These men were the O & W's telegraph operators at Sidney in 1921. From left to right are Carl F. Melvin (first trick), C. Byron Conrow (third trick), and Leslie G. Young (second trick). They are standing outside the new Sidney Union Station, which housed their telegraph office. During the railroad's personnel cutbacks of the 1920s, Melvin left the railroad; Conrow and Young moved to the Norwich and Middletown (respectively) dispatchers' offices. Both were on hand when the railroad was abandoned on March 29, 1957. (Courtesy Clyde Conrow.)

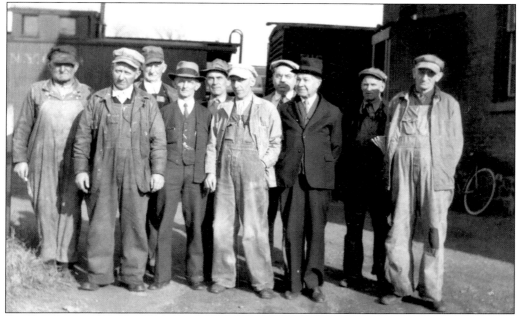

Despite the employee cutback of the 1920s, O & W railroading remained a labor-intensive affair the following decade. Pictured here are some of the men who took care of the railroad's business at Oneida. They are, from left to right, as follows: (front row) yard fireman Bill White, Harry Stanley, Elliott Emms, agent Bill Ritton, and conductor Howard Shapley; (back row) yard engineer Lew Eaton, Charles Skinner, Fred Colway, Ray Watson, and yard conductor Charles Miner. (Author's collection.)

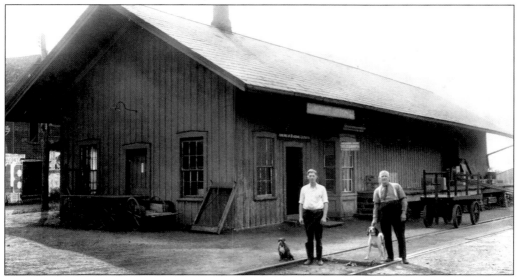

Harry Bourn (right), son of Guilford section foreman Austin Bourn, was the O & W's agent at Mount Upton for 39 years, ending in 1937. Standing in front of his O & W–built board-and-batten depot is his son Austin along with their four-legged friends. Mount Upton was home to one of the Borden Company's large condenseries served by the railroad. This depot survives as of 2003. (Author's collection.)

Jay B. Marshall (left) and Perry G. Pindar (below) were both long-term Stockbridge Valley O & W agents. Marshall's place of business was the Pratts depot for 32 years, until his retirement in 1922, and Pindar labored at the Munns depot for 28 years; he died in 1924 after only three years of retirement. Both men are buried in the Stockbridge Cemetery not far from their abandoned railroad. (Courtesy Betty Taylor, author's collection.)

Beginning on July 11, 1889, Henry A. Laufer rose through the ranks of the Ontario & Western's station service, working at Rome and Oneida before assuming his most important position as freight agent at Norwich. After 36 years of faithful service to the railroad, Laufer retired, was stricken by a debilitating disease, and admitted to the Utica Masonic Hospital, where he died in 1943. (Courtesy Chenango County Historical Society.)

For many years, the Ontario & Western's agent at Jewell was Clinton H. Drum. For a period of time, agent Drum and his wife, Stella, lived in a basement apartment under the depot, the only such underground living accommodation provided at an O & W depot. Agent Drum's O & W career began on November 6, 1899. (Courtesy Kathryn Hutchings.)

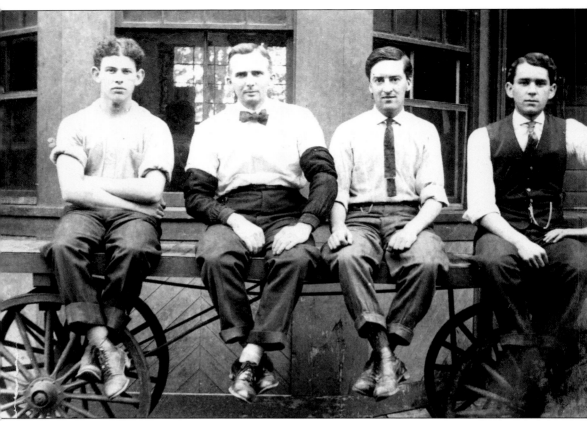

Notable among all Northern Division depots was the station situated on the east shore of Oneida Lake at Sylvan Beach. When the O & W completed their Sylvan Beach Loop in 1886, they built a rudimentary depot and named it Sylvan Beach; the surrounding seasonal community embraced the new name. A new depot was built in 1893, and for the next 33 years, seasonal employees bid for summer jobs at "the Beach." The members of the 1909 O & W station staff are, from left to right, Bob Harding (engineer Harding's son), agent Clarence Ingersoll, and telegraph operators Joe Dixon and Charlie Bonneau. (Courtesy Jack W. Farrell.)

Using the Sylvan Beach depot's bay window for support, Louis F. DeGroodt presents a dapper appearance while he was "the Beach" agent during the summer season of 1921. After 1926, the depot here was moved to a new location within the town and, for the first time in its history, became an all-year agency. By that time, however, passenger trains to Sylvan Beach had become a thing of the past. Fortunately, agent DeGroodt's employment continued for several more years. (Courtesy Janet Corby.)

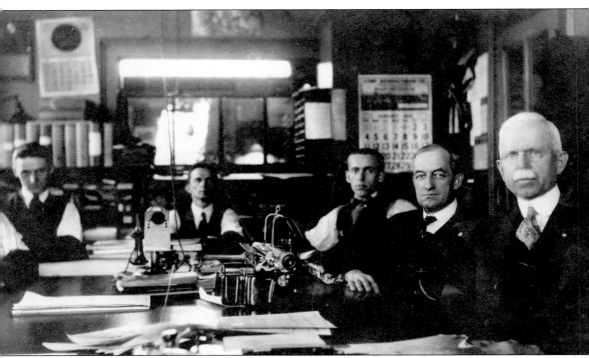

Before computers, "hard copy" paperwork was the only form for letters, waybills, car reports, manifests, and freight billing. All of this paperwork required file cabinets, boxes, ledger books, clipboards, and cubby holes, seen in this October 1919 photograph of the Oneida freight house staff. The men are, from left to right, Harold Munson, H.D. Stanley, E.H. Emms, Henry Fitzpatrick, and Charles A. Jones. If you guessed that the stern-looking Jones was the boss, you are correct. His career began on January 1, 1883, and ended 15 years after this picture was taken. (Author's collection.)

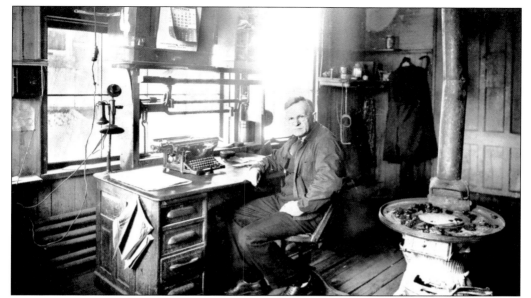

Kenwood agent Cloyce Leon Clifford began his O & W career on November 1, 1904, and retired in 1952. Twenty-seven of those years were spent in Kenwood, a station that previously had been named Oneida Community in reference to that Perfectionist group headed by John Humphrey Noyes. Leon, as he preferred to be called, contemplates his career inside that historic depot. (Courtesy Cyndi Sauter.)

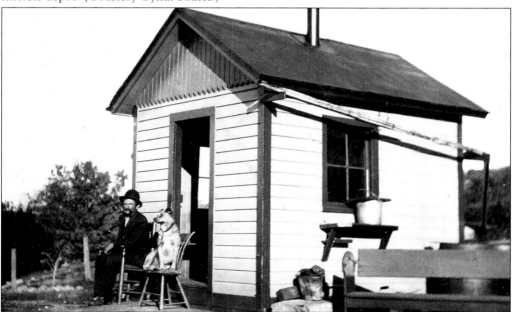

After retiring from Ontario & Western service, Tom "Diggie" Diggens was provided a small shack overlooking the Lyon Brook Bridge, where he could live out his years enjoying the scenic view of the railroad he loved. It was not too long after he moved in that he became known as the Hermit of Lyon Brook Bridge. Man's best friend was his only companion. (Courtesy Bruce Tracy.)

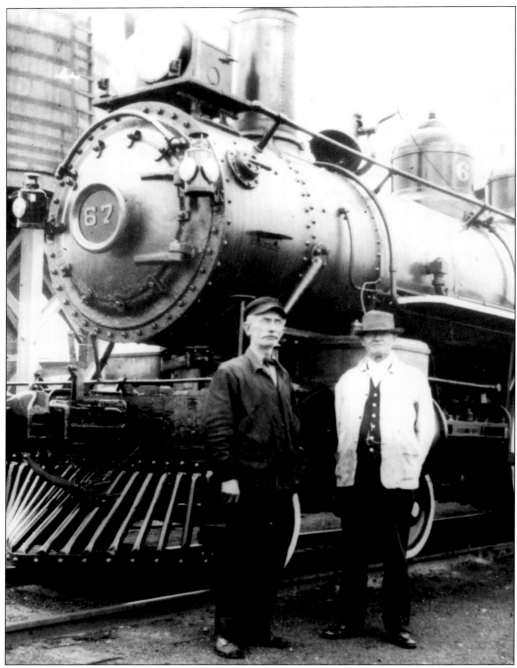

At Randallsville, engineer John Fagan (left) and trainman Gus Hill pause for a moment while their train No. 2 is being serviced. John Fagan was promoted to engineer on June 12, 1872, and was very proud when his son, John E. Fagan, became an O & W engineer on July 20, 1922. The careers of father and son almost mirrored the life span of the Oswego Midland and Ontario & Western Railroads. (Courtesy Jack W. Farrell.)

Late in his career, the younger John Fagan sits at the controls of a newfangled diesel on an Oswego-to-Norwich run. (Courtesy Jack W. Farrell.)

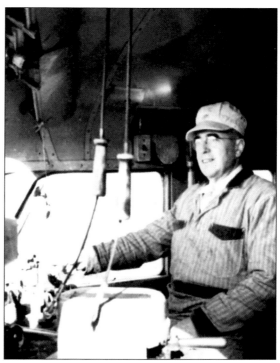

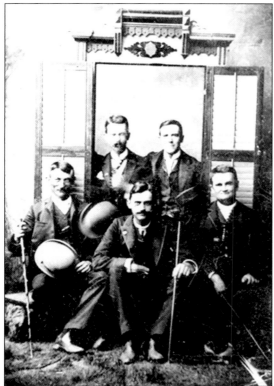

What do Ontario & Western agents do when they have time off? Why, they head off to Sylvan Beach like everyone else and have their photograph taken. These agents are, from left to right, as follows: (front row) Henry T. Lewis, Morrisville; Fred L. VanSlyke, Sylvan Beach; and Jay B. Marshall, Pratts; (back row) a young Charles A. Jones and Henry Laufer, agent and clerk, respectively, both of Oneida. (Courtesy Betty Taylor.)

123

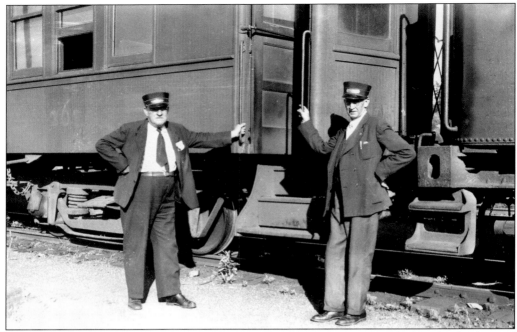

Conductor Art Simmons (left) and trainman Barker pose at Sidney just before the final run of the World War II–mandated passenger trains between there and Norwich on August 10, 1945. The world conflict was almost over, and so was the remaining Northern Division passenger service. (Courtesy Chenango County Historical Society.)

Pictured is Clarence "Deke" Soule. (Courtesy Janet Corby.)

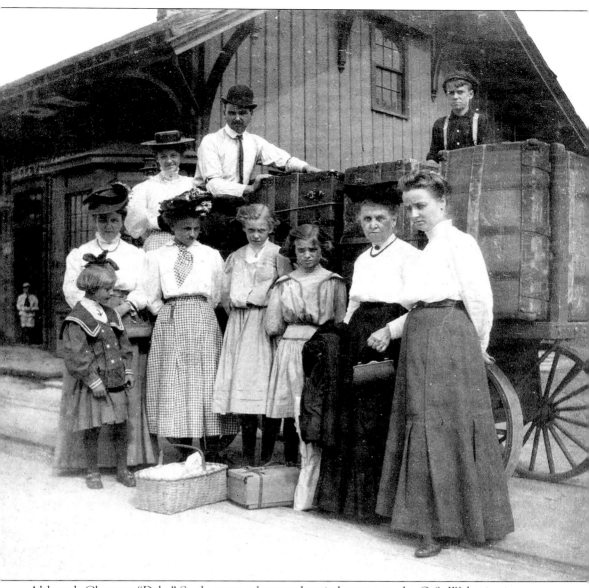

Although Clarence "Deke" Soule spent a long and varied career on the O & W, beginning on January 16, 1886, he is best remembered as the station agent at Cleveland. At that north shore Oneida Lake depot (above) Agent Soule, wearing a derby hat, oversees the handling of baggage for his sister Lizzie's family. Besides the seven Soule family ladies shown here, there was another brother, Frank, who also worked in station service for the O & W. Lizzie is second from the right. (Courtesy Janet Corby.)

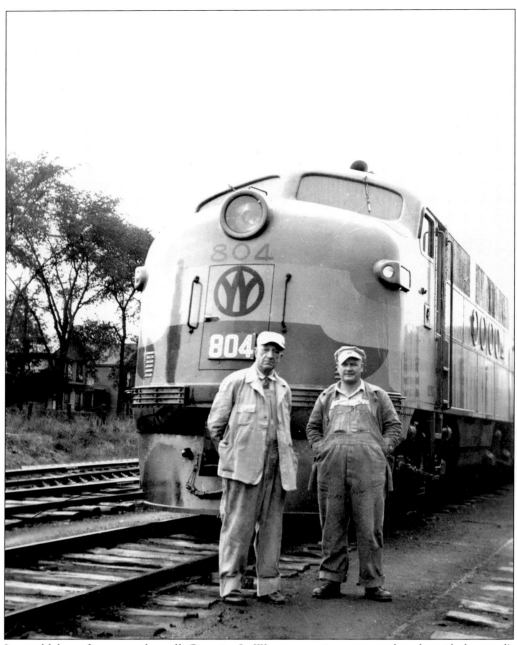

It would be safe to say that all Ontario & Western enginemen employed until the road's abandonment began their service learning about the mechanical workings of the steam locomotive and ended their service on the diesel-electric locomotives. These two enginemen— engineer Howard Baker (left) and fireman Ernest Schraft—enjoyed that transition from steam to diesel propulsion, and they are still wearing apparel associated with the bygone days of steam-powered railroading. The diesel is an EMD-built model FT unit that they will soon use to lead a northbound freight train out of Norwich. (Courtesy Chenango County Historical Society.)

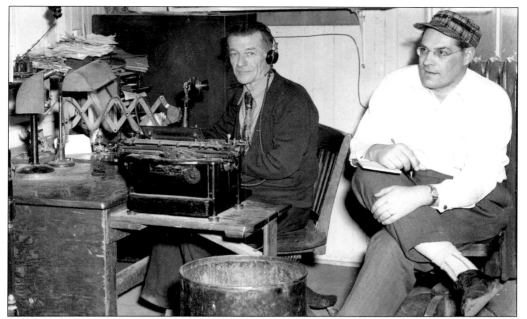

Photographed on March 29, 1957, the last day of the New York, Ontario & Western Railway's operation, Oneida agent William J. "Jimmie" Sheehan and waybill Clerk Ray Hall are just beginning to realize that tomorrow will not bring another day of work on the railroad. Their office was in the freight house, as the passenger station had been razed in 1939. (Author's collection.)

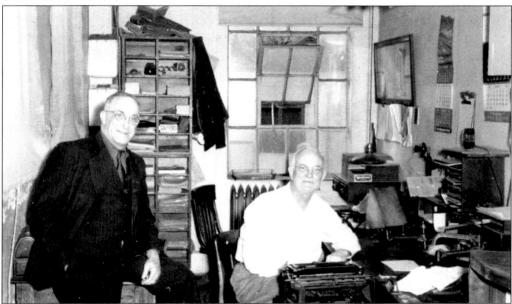

The last men in charge of the O & W's operation in Norwich were trainmaster Tom Natoli (left) and agent–crew dispatcher C. Byron Conrow. From their freight house office, the final business of the railroad was handled when Byron's evening counterpart, Ray McElligott, wrote the final train order on March 29, 1957. (Courtesy Clyde Conrow.)

FORM
19

FORM
19

Form T.D. 11-AA
New York, Ontario and Western Railway
LEWIS D. FREEMAN, TRUSTEE

TRAIN ORDER NO. 24

Mtown Mch 29, 19 57

To _Cand E Eng 805_ At _Norwich_

X..................................OperatorM.

Eng 805 Run Extra

Norwich to Middletown.

J.B.G.

CONDUCTOR AND ENGINEMAN MUST EACH HAVE A COPY OF THIS ORDER

Made _Complete_ Time _824_ p. M. _R. M. Elligott_ Operator

This Form 19 is widely considered to be the last telegraphic train order sent out over the wires of the New York, Ontario & Western Railway. When Extra No. 805 South passed Norwich on the evening of March 29, 1957, the sounds of O & W railroading in that Chenango County seat came to an end and disappeared forever. (Courtesy Clyde Conrow.)